BALDESSARI

While something is happening here,
something else is happening there

Works 1988–1999

Spectrum – Internationaler Preis für Fotografie der Stiftung Niedersachsen

BALDESSARI

While something is happening here, something else is happening there

WORKS 1988 – 1999

Texte von/Texts by Meg Cranston, Diedrich Diederichsen und/and Thomas Weski

Inhalt/Contents

Ich glaube, ich hasse Antworten

I guess I hate answers

Das Werk des amerikanischen Künstlers John Baldessari ist neben seiner formalen Sicherheit durch ein großes assoziatives Potential bestimmt, das durch die Kombination verschiedener Elemente entsteht. Diese Bestandteile, die verschiedenen Ursprungs und Charakters sein können, treffen vom Künstler konstruiert im Bild aufeinander und treten in einen formalen und inhaltlichen Dialog mit offenem Ausgang. "Es ist so, als ob ich im Flugzeug zwei Gesprächen zuhöre: einer sagt etwas und irgendein anderer sagt etwas anderes. Ich könnte mir diese Sätze nicht ausdenken, aber ich reagiere auf sie, indem ich sie miteinander verbinde, aus ihrem Kontext nehme und sie zu einem Teil meiner Imagination mache."[1]

Ende der 60er Jahre lebt John Baldessari in National City, einem Vorort von San Diego im Süden Kaliforniens, in dem er 1931 als Sohn europäischer Emigranten geboren wurde. Hier hat er ein bescheidenes Atelier in einem Gebäude aufgeschlagen, das seinem Vater, einem früheren Immobilienhändler, gehört. Über Wasser hält sich der bislang wenig erfolgreiche Künstler mit mehreren parallel ausgeübten Lehraufträgen. Die direkte Umgebung, die durch die Ansiedlung industrieller und kommerziell ausgerichteter Kleinbetriebe gekennzeichnet ist, liefert Baldessari das visuelle Ausgangsmaterial für die erste Werkgruppe, die den Künstler bekannt macht. Es handelt sich um fotografische Schnappschüsse urbaner Szenen von National City, die der Serie auch den Titel gibt. Die oft aus dem Auto heraus aufgenommenen Schwarzweißfotografien widersprechen allen Regeln einer Kunst der Fotografie der damaligen Zeit, die auf ausgewogene Komposition, reiche Darstellung der Grauwerttöne und bedeutsame Inhalte abzielt. John Baldessari begibt sich auf fotografisches Terrain, bricht mit

The work of the American artist John Baldessari is distinguished not only by a remarkably sure-footed approach to form but also by an enormous associative potential based on a combination of elements of completely diverse origin and character. These component elements are brought together in a context of the artist's own making and are made to conduct a dialog which, in terms of both form and content, is open-ended. "It's like when I am in an airplane cabin and overhear two conversations: one says something and another says something else. I could not have thought up those phrases on my own, and I respond to it by connecting one to the other, taking both out of their own context, and by making them a part of my imagination."[1]

Around the end of the sixties, John Baldessari is still living in National City, a suburb of San Diego in South California, where he was born to European immigrants in 1931. It is here that he has set up a modest studio in a building belonging to his father, a former realtor. Not having been all that successful as an artist so far, John Baldessari keeps his head above water with teaching jobs. His immediate urban environment, marked its many small factories, workshops and businesses, furnishes Baldessari with the visual starting material for the series of works through which he first became known. They are photographic snapshots of urban scenes of National City, from which the series also takes its title. These black-and-white photographs, often shot from a car, disobey all the rules of art photography of the time, for they pay no heed to compositional balance, tonal values or significance of content. Indeed, in venturing into photographic terrain, John Baldessari breaks with all prevailing conventions, creating, through a

allen herrschenden Konventionen und schafft mit einem konzeptuell begründeten Vorgehen Kunst mit Fotografie. Die Aufnahmen werden nicht auf standardisiertem Fotopapier abgezogen, sondern direkt auf eine mit einer lichtempfindlichen Silberschicht versehenen Leinwand belichtet und haltbar gemacht. Das Auftragen der fotografischen Emulsion ist umständlich und schwierig, die Resultate fallen qualitativ unterschiedlich aus. Die so entstehenden Fotografien haben einen malerischen Charakter, der aber unperfekt und provisorisch wirkt. Die in der Regel horizontal aufgenommenen Fotografien werden in der oberen Hälfte des hochformatig genutzten Bildträgers plaziert. Im unteren Teil der ansonsten unbehandelten weißen Leinwand wird der Aufnahmeort in einem kurzen Text topographisch verankert und das Motiv benannt. Die Schrift folgt wie die Anordnung der Fotografien einer durchgängigen Gestaltung und wird von einem vom Künstler beauftragten Schildermaler aufgetragen. Das fertige Bild, immer ein Unikat, vereint verschiedene Formen der Kommunikation und Quellen der Information – die Fotografie und die Schrift – und verankert das Werk durch den Gebrauch der Leinwand im Kontext der Kunst. "Ich glaube, es ging darum, mein Schicksal zu akzeptieren und damit klar zu kommen. Zu diesem Zeitpunkt meines Lebens dachte ich, daß ich nur an der High School unterrichten, Familie und Kinder haben und einige Arbeiten für meine Freunde machen würde. Wahrscheinlich würde ich niemals aus National City rauskommen. Daher wollte ich den Leuten zeigen wie es dort ist. Ich wollte Kunst aus meinem Umfeld heraus und mit ihm machen ohne es aufzuwerten und mit der Idee, daß Wahrheit schön ist, egal wie häßlich sie ist."[2]

In der Folge beschäftigte sich Baldessari mit den verschiedenen Möglichkeiten der Kombination fotografischer Motive. In seinen "Combined Photographs" fügt er Bilder aus verschiedenen fotografischen Quellen zusammen. Während er in den frühen Text-Fotoarbeiten noch eigene Fotografien als Rohmaterial einsetzt, benutzt er bei den Bildkombinationen in den nächsten Jahren fast ausschließlich Vorlagen aus fremder Hand, die er aus seinem sorgfältig angelegten Archiv zieht.

unique conceptual approach, art with the medium of photography. The prints are made not on normal photographic paper but on canvas coated with a light-sensitive silver-halide emulsion and then developed and fixed. The work of applying the photographic emulsion to the canvas is a difficult, involved procedure, and the resulting photographic prints have a painterly yet imperfect, temporary character. Normally of horizontal format, the prints are placed in the upper half of the vertical-format canvas. In the lower half of the otherwise untreated white canvas is a short text which tells us the location and title of the photograph. Like the arrangement of the photographs, the texts follow a consistent pattern and Baldessari has them written by a professional sign-writer. The finished picture, which is always a unique exemplar, combines different forms and sources of information – photography and calligraphy – and, by virtue of its canvas support, places the work in the context of art. "I think it was about accepting my destiny, and coming to terms with it. At that point of my life I thought all I was going to do was teach in high school, you know, have a family and kids, and do some work for my friends. Probably I was never going to get out of National City, so I was going to show people what it's like, to make art out of where I lived without glamorizing it, and with the idea that truth is beautiful, no matter how ugly it is."[2]

Baldessari continues to experiment with various possible ways of combining photographic images. In his "Combined Photographs", Baldessari utilizes photographic material from various sources. Whilst in his early photo-and-text pieces he still used his own photographs as raw material, the image combinations produced during the years that follow are made almost exclusively from "outsourced" photographs which he stores in a carefully kept archive. This material mainly comprises stills from American movies which, in excerpt form, are brought into a fruitful dialog by the artist. These fragments of artificially charged, dramatically exaggerated movie scenarios serve as an ideal means of conveying to the viewer a familiar, collective feeling of recognition, but then this feeling is

Vor allem sind es die Standfotografien amerikanischer Filme, aus denen Baldessari Ausschnitte in einen fruchtbaren Dialog setzt. Die Details der künstlich aufgeladenen und dramaturgisch überhöhten Filmsituationen eignen sich besonders, um dem Betrachter das Gefühl einer vertrauten kollektiven Kenntnis zu vermitteln, das aber durch das Arrangement des Künstlers gründlich gestört wird. Baldessari überträgt auf seine Bildkombinationen die Theorie des surrealistischen Filmschnitts. In dem 1928 entstandenen Film "Un chien andalou" von Luis Bunuel und Salvador Dali folgt auf die Darstellung des Gesichts einer jungen Frau nach dem nächsten Schnitt eine Großaufnahme eines Auges, das automatisch als das der Frau empfunden wird und durch das in der nächsten Szene zum Entsetzen der Betrachter ein Rasiermesser schneidet. Die eben noch gewöhnliche Sicht auf ein menschliches, extrem empfindliches Organ wird in der Kombination mit dem aggressiven Eingriff zum Schockerlebnis. Baldessari nutzt diese Methode der visuellen Konfrontation verschiedener Motivwelten. Auch seine Bildelemente zeigen in der Kombination auf einmal ihr anderes Gesicht. Die Abfolge der Bilder oder ihre Anordnung sind bei ihm ebenfalls nie zwingend logisch, und so entstehen dem Betrachter Lücken, blinde Flecken zwischen den Segmenten, die ihn dazu bringen, eigenständige assoziative Arbeit zu leisten. Dazu tragen auch die übermalten, herausgeschnittenen oder mit farbigen Punkten bedeckten Bildteile bei. Die so angereicherten, umcodierten, in einen anderen Bedeutungszusammenhang überführten Bildausschnitte und -partikel werden durch die Form ihrer Montage zu neuen Bildern, die eine schnelle Antwort verweigern – aber auch ihre allgemeingültige Analyse. Bei eingehender Betrachtung scheinen die Bilderrätsel zunehmend verschlossener und gleichzeitig durch dieses Sich-Entziehen attraktiver zu werden. "Im libidinalen Zentrum der Arbeit steht nicht die Entdeckung der Wahrheit, sondern die Freude am Sehen. Es geht um die Erotik des Blicks – und die Teilhabe daran."[3]

Die Ästhetik der ausgeklügelten Arrangements dieser Werkphase, in denen Baldessari alle möglichen Variationen der

thoroughly destroyed by the way the artist arranges them. Here Baldessari avails himself of the surrealist technique of film editing, as used, for example, by Luis Bunuel and Salvador Dali in the film "Un chien andalou", made in 1928: the close-up a young woman's face is immediately followed by an extreme close-up of an eye which is naturally thought to be that of the woman. In the next scene, to the horror of the audience, the eye is slashed with a razor. This combination of images, the one being just a normal view of a human eye, an extremely sensitive organ, the other a view of an aggressive incision, creates an effect of immense shock. Baldessari uses this method of visual confrontation with images from completely different worlds. The individual elements of his pictures, too, suddenly reveal themselves in a different light. The sequence of the images, or their arrangement, is not necessarily logical, and the resulting lacunae, the blind spots between the segments, force the viewer to search for his own associations. This search is made still more difficult by the fact that certain parts of the images have been overpainted, cut out, or covered with colored spots. These enriched, recoded parts and fragments of images not only enter a completely different context of meaning but also become, through the way they are montaged, completely new images, images which refuse to give any fast answers and even deny analysis in the generally valid sense. The longer we look at them, the more these picture puzzles seem to be inaccessible and yet, through the very fact of their inaccessibility, more attractive. "It is not the discovery of truth that is at the libidinal center of the work, but the pleasure of looking. It's about the eroticism of the gaze – and our participation in it."[3]

The esthetic of Baldessari's cleverly devised arrangements, which he plays through in all possible variations, often heightening the tension by stretching the physical distance between individual elements to its very limits, has given him the reputation of a formalist, as Meg Cranston points out in her interview with Baldessari in this catalog. This is, in my opinion, much too hasty a judgement, for it disregards an

Anordnung durchspielt und ihnen oft durch die räumliche Distanz der verschiedenen Elemente zusätzliche Spannung verleiht, hat ihn, wie Meg Cranston in ihrem in diesem Katalog abgedruckten Interview mit dem Künstler zitiert, in den Ruf eines Formalisten gebracht. Und doch ist mit diesem Etikett zu schnell geurteilt und, wie mir scheint, eine wesentliche Qualität des Werkes von Baldessari übersehen: Er hat der in der Regel lediglich auf die Illustration der Idee fixierten Konzeptkunst das sinnliche Moment eines verführerischen Bildes hinzugefügt und uns gelehrt, daß Sehen auch im Kontext dieser Kunst Spaß machen darf, ohne dabei den mediumsanalytischen Charakter zu verlieren. Daß wir darüber hinaus auch noch mit feinsinniger Ironie, Wort- und Bildwitz beschenkt werden, bringt uns in den Genuß einer raren intellektuellen und sinnlichen Hirn- und Augenlust.

In den 90er Jahren löst Baldessari sich von den üblichen rektakulären Bildformaten und schneidet amorphe Formen aus seinen Vorlagen, die er mit malerischen Mitteln nachbearbeitet und erweitert. Diese Arbeiten gehen bei aller scheinbaren Leichtigkeit bis ans Ende der gestalterischen Möglichkeiten. Fast hat man das Gefühl, daß der Künstler hier eine Grenze hin zur Abstraktion spürt, die er nicht überschreiten möchte, denn Mitte der 90er Jahre folgt dann wie in einem Akt der Rückversicherung auf bereits erarbeitete Grundlagen die Wiederaufnahme seiner Text-Foto-Arbeiten. John Baldessari, der inzwischen in Santa Monica und New York lebt, kehrt an seinen Geburtsort National City zurück und refotografiert dort nach dreißig Jahren die Motive seiner frühen Serie und ergänzt sie um neue Ansichten. Natürlich haben sich die lokalen Situationen geändert, einige der Objekte haben neue Funktionen, andere existieren nicht mehr. Wie die Bilder aus den 60er Jahren, präsentiert der Künstler seine Fotografien auf Leinwänden mit Texten, die die Aufnahmegegenstände und -orte benennen. Neben einem autobiographischen Aspekt (so zeigt "1121 East Second Street, National City, Calif." das von Baldessaris Vater gebaute Haus, in dem der Künstler aufwuchs) beeindruckt mich bei dieser neuen Serie vor allem die latent angelegt

essential quality of Baldessari's work: Baldessari has added to concept art, which as a rule is concerned purely with the visualization of an idea, a moment of sensuality and seduction, and has taught us that the process of seeing, even in the context of this genre of art, can still be pleasurable without losing sight of its media-analytical purpose. That Baldessari also operates with subtle irony and verbal and visual humour affords us, in addition, rare delights for both the mind and the eye.

In the nineties, Baldessari waives the rectangular format in favor of irregularly shaped, cut-out elements which he overpaints. Despite the apparent ease with which these works are executed, Baldessari pushes their creative potential to its limits. One almost feels that Baldessari senses the boundary between the concrete and the abstract and does not wish to cross it. Indeed, it is about this time, the middle of the nineties, that Baldessari reverts – in a kind of act of reassurance – to an already existing strategy and resumes work on his photo-and-text pieces. Now residing in Santa Monica and New York, John Baldessari returns to his native National City and rephotographs, after a time lapse of thirty years, the motifs of his early series, complementing them with new views. The local situations have of course changed in the meantime, some objects having completely new functions, others no longer in existence. As in the sixties, Baldessari prints these photographs on canvas with accompanying texts which name the objects and their locations. What impresses me most about this new series, besides the biographical aspect (the piece entitled "1121 East Second Street, National City, Calif." shows, for example, Baldessari's parental house which was built by his father), is the latent reference to the before-and-after differences between the images, for it clearly shows a feeling for the lapse of time and its significance. A contributory factor in this regard is Baldessari's use of black-and-white photography – quite an uncommon medium nowadays – which, psychologically, conveys the idea of completion, of something having taken place in the past, and thus

formulierte Differenz zwischen Vor- und Nachbild, die deutlich ein Gespür für die Bedeutung für das Verstreichen von Zeit trägt. Dazu trägt auch der Gebrauch der heute schon fast unüblichen Schwarzweißfotografie bei, die wahrnehmungspsychologisch deutlich auf die Abgeschlossenheit einer Handlung verweist, also ihren dokumentarischen Charakter zitiert. Durch den Einsatz der Farbfotografie – die nach Ansicht des amerikanischen Filmtheoretikers Stanley Cavell jetztzeitig wirkt und vermeintlich sogar ein zukünftiges Moment in sich trägt – bei den anderen Arbeiten der Serie könnte man ironisch anmerken, daß Baldessari National City zum Modell der ewigen amerikanischen, kapitalistisch geprägten Stadt erhebt, deren Signifikanten sich aus Straßenkreuzungen, Telefonmasten und Autosalons generieren. Bei allem Augenzwinkern darf man aber auch hier nicht übersehen, daß die genannten scheinbar banalen Objekte natürlich auch als Metaphern für Kommunikation, Mobilität und Urbanität dienen und die Bilder dieser Serie so unter ihrer durchaus ästhetischen Oberfläche auch eine inhaltliche Ebene tragen, die eine Darstellung heutiger gesellschaftlicher Verhältnisse formuliert.

Die künstlerische Auseinandersetzung mit der dialektischen Verknüpfung von Text und Bild führt John Baldessari auch in den darauf entstehenden Arbeiten, in den "Goya"- und "Elbow"-Werkgruppen fort. Bildtitel der fast zweihundert Jahre alten Serie "Desastres de la guerra" des von Baldessari geschätzten spanischen Künstlers Francisco Goya y Lucientes werden in Bezug gesetzt zu Fotografien heutiger alltäglicher Gegenstände. Auf beeindruckende Weise spielt hier Baldessari mit der Transfermöglichkeit der Bildunterschriften Goyas in die heutige Zeit. Wie bei allen Text-Foto-Arbeiten Baldessaris informieren die Bilder den Betrachter auf zwei verschiedene Wege. Die Fotografie, populärstes Bildmittel unseres Jahrhunderts, wird durch eine Unterschrift ergänzt, die aber die Faktizität des technisch hergestellten Bildes mit anderen Mitteln verdoppelt, so unterläuft und in Frage stellt. Nach einem ersten stillen Einverständnis herrscht Verwirrung beim Betrachter. Dieses rezeptive Chaos führt aber zur eigenen

has a documentary function. Baldessari's use, in the other pieces of the series, of color photography – which according to the American film theorist Stanley Cavell creates an effect of nowness, possibly even with a futuristic overtone – might readily provoke the ironical comment that the artist has raised National City to the status of a typically American, capitalist township whose characteristic features are intersecting roads, telegraph poles and used-car sites. But for all our winking, we must not overlook the fact that these apparently banal objects also serve as metaphors for communication, mobility and urbanity, and that, beneath their purely esthetic, formal surface, the images of this series also operate on another level, one of content, through which the artist conveys his view of modern social conditions.

Text and image combinations are also a feature of the works that follow – the "Goya Series" and "Elbow Series". Titles from "Los Desastres de la Guerra", the cycle of etchings produced almost two hundred years ago by Francisco Goya y Lucientes – Baldessari holds this Spanish artist in great esteem – are here linked with photographs of modern everyday objects. What is quite impressive about his "Goya Series" is the way Baldessari plays with the possibility of relating the titles of Goya's etchings to modern situations. As in all Baldessari's photo-and-text pieces, the viewer receives information in two different ways. The photograph, the most popular imaging medium of our century, is complemented by a caption which augments the facticity of the technically produced image through its association with other media, thus undermining it and calling it into question. Whilst we, the viewers, might indeed be able to go along with it at first glance, we become more confused the longer we look at it. It is precisely this confused reception that forces us to set out in search of our own associations and, in so doing, abandon our role of the passive observer. This in turn makes us realize that Baldessari is not only confronting us with visually inspiring and exciting images but is also informing us, in a seemingly playful way, about the authenticity of photography and its possible misuse.

assoziativen Mitarbeit – wir verlassen also die Rolle des passiven Betrachters –, die dann in der Folge die Erkenntnis zuläßt, daß Baldessari uns nicht nur mit visuell an- und aufregenden Bildern versorgt, sondern uns scheinbar spielerisch genauso viel über die Authentizität der Fotografie und ihren möglichen Mißbrauch berichtet.

Es ist auffallend, daß Baldessari bei seinen letzten Arbeiten aktuelle kommerzielle Bildherstellungsverfahren wie den Ink-jet-Druck und den Folio D Prozeß für seine künstlerischen Zwecke einsetzt. Auch diese fehlende Berührungsangst macht ihn zu einem Vorbild für eine junge Künstlergeneration, die ebenfalls die neuesten medialen Mittel ganz selbstverständlich erprobt. Neben diesem technischen Aspekt spielt aber die Methode der Konstruktion des Kunstwerkes die Hauptrolle bei der nicht nachlassenden Anerkennung des Künstlers. Baldessari kann im Bereich der Bildenden Kunst als der Erfinder des *sampling* begriffen werden, also der Neuschaffung eines Werkes durch die Synthese und Umdefinition verschiedener Teile unterschiedlicher Provenienz. Neben dem mediumsanalytischen Ansatz liegt die Qualität seiner künstlerischen Arbeit für mich in der dialektischen Verbindung der formalen Ausführung der Aussage(n). Auch Baldessaris nicht nachlassendes Interesse am kontinuierlich durchgeführten künstlerischen, konzeptuell begründeten Prozeß – der Weg ist das Ziel – bei der Erforschung des labilen, perfekt unperfekten Gleichgewichtes macht ihn zu einem Ausnahmekünstler unserer Zeit: "Die Jagd ist interessanter. Ich halte Dinge immer gerne offen und hasse es, sie fertigzustellen. Während ich noch an der einen Sache arbeite, denke ich immer schon an die nächste; ich glaube, ich hasse Antworten."[4]

Whereas Baldessari digitized his black-and-white photographs for his "Goya Series" and then had them printed in ink-jet on canvas, he chose the Folio D process for his "Elbow Series". A particularly noticeable aspect of Baldessari's artwork is his use of modern commercial imaging processes. The fact that he is not afraid of using such modern media makes Baldessari the perfect role model for the young generation of artists for whom the latest imaging technologies are likewise a readily acceptable artistic medium. However, it is not so much this technical aspect than Baldessari's method of constructing his artwork that has contributed primarily to his continued acclaim. Indeed, Baldessari may, in the context of the visual arts, be regarded as the inventor of *sampling*, the process of creating a completely new work of art by synthesizing and redefining various elements of different origins. For me, the quality of Baldessari's art lies not just in his media-analytical approach but also in his formal, dialectical combinations of text/image and image/image. And it is not least his untiring interest in the continuous, conceptually motivated search – "The way is the goal" – for an unstable, perfectly imperfect equilibrium that makes Baldessari one of the exceptional artists of our time: "The chase is more interesting. I always seem to prefer to keep things open, and I hate to bring things to completion. When doing one work, I am always thinking of the next; I guess I hate answers."[4]

[1] John Baldessari zit. in: Coosje van Bruggen, Interlude: Between Questions and Answers, John Baldessari, New York 1990, S. 19

[2] ebda., S. 27

[3] Thomas Lawson, Das Theater des Geistes. John Baldessari, in: Parkett, Nr. 29, S. 43

[4] John Baldessari zit. in: Coosje van Bruggen, Interlude : Between Questions and Answers, John Baldessari, New York 1990, S. 70

[1] John Baldessari, quoted from: Coosje van Bruggen, Interlude: Between Questions and Answers, John Baldessari, New York, 1990, p. 19

[2] Ibid., p. 27

[3] Thomas Lawson, Das Theater des Geistes. John Baldessari, in: Parkett, No. 29, p. 43

[4] John Baldessari, quoted from: Coosje van Bruggen, Interlude: Between Questions and Answers, John Baldessari, New York, 1990, p. 70

John Baldessari: Viele wertvolle Seiten

Als ich Ende der 80er Jahre bei John Baldessari studierte, hatte John die nervige Angewohnheit, eine Arbeit zu loben, indem er von unendlich vielen, verwandten Arbeiten sprach, die ihr noch folgen könnten. Ich erinnere mich daran, wie ich ihm einmal ein kleines Bild von mir zeigte, auf dem der Rocksänger Tom Petty zu sehen war. Während meine anderen Lehrer das Bild verdammten, weil sie es so unkritisch fanden, hatte Baldessari kein Problem mit der prosaischen Wahl meines Sujets. Er lobte sogar meinen Farbauftrag, bewunderte den ihn an de Kooning erinnernden Schwung bei der Darstellung des Gesichts und den lächerlichen Einsatz des Palettenmessers bei der Gestaltung des Haars. Aber das war natürlich Komödie.

Was Baldessari wirklich wissen wollte, war, warum ich nicht auch John Lennon oder Sid Vicious gemalt hatte? Er wollte wissen, ob ich die Absicht hatte, noch Porträts von Brian Ferry oder Boy George, von Keith Richards, Keith Moon oder Mozart zu machen. Da ich im Grunde für die Arbeit außer meiner Trägheit keine Erklärung hatte, behauptete ich, ich hätte nur Geld für eine einzige Leinwand gehabt. Er dachte einen Augenblick darüber nach und breitete dann eine der für ihn typischen, total irritierenden und höchst überzeugenden hypothetischen Situationen aus.

Angenommen, ich hätte eine unbegrenzte Zahl von Leinwänden oder irgendwelche anderen passenden Malgründe, könnte ich mir dann vorstellen, eine ganze Galaxie männlicher Rockstars zu malen? Und angenommen, ich hätte sie beendet, würde ich dann vielleicht auch noch Porträts weiblicher Rockstars malen – zum Beispiel Chrissy Hynde oder Janis Joplin?

John Baldessari: Many Worthwhile Aspects

Back in the late 1980's, when I was John Baldessari's student, John had this maddening habit of praising a work by suggesting the endless number of related works that might follow it. I remember showing him a small painting I did of the rock singer, Tom Petty. Unlike my other teachers who condemned the work for its utter lack of criticality, Baldessari had no problem with my prosaic choice of subject matter. He even praised the paint handling – admiring the de Kooning like swirl of colors in the face and my rather ludicrous use of a palette knife in the hair. But that, of course, was a set-up.

What Baldessari really wanted to know was why I hadn't also painted John Lennon, or Sid Vicious? He wanted to know if I had considered painting portraits of Brian Ferry or Boy George, or Keith Richards or Keith Moon or Mozart for that matter? Having no real explanation except laziness, I claimed I only had money for one canvas. He thought about that for a moment and then suggested one of his super irritating and highly persuasive hypothetical situations.

Assuming I had an unlimited number of canvases or could find some suitable substitute, couldn't I paint a whole galaxy of male rock stars? Assuming I could accomplish that, would I also consider portraits of female singers – Chrissy Hynde or Janis Joplin? Would Madonna be included, or rejected on some grounds? It went on and on like that. Finally I had to throw up my hands and insist I only wanted to paint Tom Petty and I wasn't even all that keen about him so stop bothering me.

Of course, had I listened to John I would have probably become Elizabeth Peyton, which could have been all right but

Wäre Madonna unter ihnen, oder gäbe es möglicherweise einen Grund, sie auszuschließen? So ging das immer weiter. Am Ende warf ich die Arme in die Luft und erklärte, ich habe nur Tom Petty malen wollen, und eigentlich sei ich auf ihn auch nicht besonders scharf gewesen. Ich wollte nur noch, daß das aufhört.

Klar, hätte ich auf John gehört, wäre ich vielleicht Elizabeth Peyton geworden. Das wäre vielleicht nicht das Schlechteste, aber das ist nicht der Punkt. Der Punkt, um den es Baldessari geht, ist immer etwas anderes. Es ist dies *und* das. Ihn interessiert nicht nur die Wahl, die wir treffen, sondern all die Optionen, die wir dabei ausschließen. Wie er mit dem Titel dieser Ausstellung sagt: Während hier das eine geschieht, geschieht dort etwas anderes.

Fünfzehn Jahre später habe ich nun die Gelegenheit zu erfahren, wie John Baldessari sich selbst erklärt. Das Interview fand statt am 9. Juli 1999 in Baldessaris Atelier in Santa Monica.

Meg Cranston: Kannst Du etwas zum Titel der Ausstellung sagen?

John Baldessari: Er klingt ein bißchen, wie das Geständnis eines Kokainschnupfers – ich kann nicht hier sein, weil dort die bessere Party ist. Als ich noch malte, war es ganz ähnlich. Ich hab mich kaputt gemacht, um ein Bild fertig zu kriegen, sah dann irgendwelches Zeug in der Ecke meines Ateliers und dachte: Das ist viel besser als das, was Du hier machst.

MC: Viele Deiner Titel erinnern mich an Aphorismen. Mir fällt dabei Nietzsche ein, der unter allen Textformen den Aphorismus am meisten liebte. Er sah es als sein besonderes Talent an, viel Philosophie in einen einzigen Satz oder Absatz packen zu können. Trifft das auch auf Dich zu?

that's not the point. The point is, with Baldessari it's always something else. It's this *and* that. He's not only interested in the choices one ultimately makes but in the whole universe of options we reject. As he says in the title of this exhibition; while something is happening here, something else is happening there.

Now, nearly fifteen years later, I have the chance to get John Baldessari to explain himself. This interview took place on July 9, 1999 in Baldessari's Santa Monica studio.

Meg Cranston: Can you describe the title for the show?

John Baldessari: It almost sounds like a coke addict's confession – I can't be here because there's a better party over there. (*laughs*) I suppose the idea is while you focus on one thing here there is something else over there. It's like when I used to paint, I'd be busting my ass on a painting and then look over in the corner at some trash and think that's much better than what I'm doing.

MC: I view many of your titles as aphorisms. I think of Nietzsche, who said his favorite form was the aphorism – he felt it was his particular talent to pack a lot of philosophy into a single sentence or paragraph. Could that also describe you?

JB: I've always appreciated Nietzsche for that and also Wittgenstein. I appreciate that kind of style where you can pack the most into smallest amount of time. That's why I like Matisse, he seems very simple. Or Giotto, he tried to make a thing look easy. I think somehow that's always been a touchstone for me that it should look really sort of easy but with luck have profundity too which is almost a paradox. I hate things that look clotted in any way. But, having said that that's fascinating too. Now and then I like to be completely baroque,

JB: Ich habe Nietzsche für diese Gabe immer geschätzt und auch Wittgenstein. Ich mag eine Form, in der man in aller Kürze ganz viel unterbringt. Daher mag ich auch Matisse. Er ist scheinbar ganz einfach. Oder Giotto, er hat versucht, daß die Dinge einfach aussehen. Für mich war das immer ein Prüfstein, daß etwas einfach aussieht und doch komplex ist, was sich wie ein Paradox anhört. Ich mag Dinge nicht, die irgendwie kompliziert aussehen. Aber eigentlich sind die auch faszinierend. Manchmal liebe ich es, barock zu sein, so daß es einem fast den Atem nimmt, nur so zum Spaß. Aber müßte ich wählen, dann die Einfachheit.

MC: Glaubst Du, daß Dich die Pop Art in ihrer Einfachheit beeinflußt hat?

JB: In dieser Hinsicht schon. Ich mag einfache Dinge sehr. Ich glaube, das hat auch mit dem Minimalismus zu tun. Wie weit kannst Du reduzieren, ohne Dein Publikum zu verlieren. Das erinnert mich an William Carlos William, der mich sehr beeinflußt hat mit seinen Texten aus Einsilbern, mit seiner schlich-

almost asphyxiating, just for the hell of it. But if I had to choose I would choose simplicity.

MC: Do you think visually you were effected by Pop Art – the easy look of it?

JB: In that sense yes, I like simple objects a lot. I guess that's a minimalist attitude too; how reductive can you be without losing your audience. It makes me think of William Carlos Williams, who always influenced me with his use of monosyllabic simple structure. Deceptively simple.
Also, a lot of my attitude has come from using the camera and photographing real insignificant stuff. All of a sudden it becomes significant if you see it the right way. I'm suspicious of things that look important. I'm more interested in things that have escaped attention.

MC: In the original National City pieces (1966 – 68) and the continuation of that series that appears in this show, were you're trying to make the places in National City more beautiful by describing them – by photographing them and putting them on canvas?

JB: No. At the time when I did those I just thought I was like a war correspondent. I was coming to terms with myself. I guess that was my warts and all period.

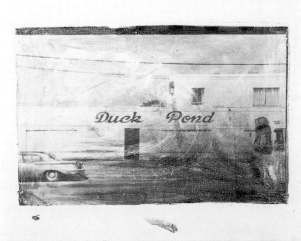

DUCK POND BAR, NATIONAL CITY, CALIFORNIA

DUCK POND BAR, NATIONAL CITY, CALIFORNIA
1967
Acrylfarbe und Fotoemulsion auf Leinwand/
Acrylic and photo emulsion on canvas
152 x 170 cm/60 x 67 inches
Private collection, Germany

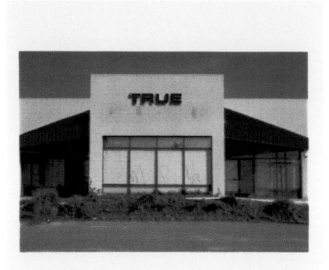

**FORMER SITE OF DUCK POND BAR
3003 NATIONAL CITY BLVD.
NATIONAL CITY, CALIF.**

THE FORMER SITE OF DUCK POND BAR,
3003 NATIONAL CITY BLVD., NATIONAL CITY,
CALIFORNIA

1996

Acrylfarbe und Fotoemulsion auf Leinwand/
Acrylic and photo emulsion on canvas

150 x 114 cm/59 x 45 inches

Courtesy Philomene Magers – Monika Sprüth,
Munich/Cologne, and Sonnabend Gallery, New York

ten Struktur. Für hochgespannte Erwartungen enttäuschend
schlicht.

Mein Stil erklärt sich aber auch so: Als ich anfing zu fotogra-
fieren, habe ich ganz unbedeutende Dinge fotografiert. Sie
werden dann bedeutsam, wenn man sie richtig ansieht. Ich bin
Dingen gegenüber mißtrauisch, die wichtig aussehen. Mich in-
teressieren eher Dinge, die sich der Aufmerksamkeit entziehen.

MC: In den ersten National City Arbeiten (1966–68) und
später in den neuen Bildern, die diese Serie fortsetzen – sie
werden hier in der Ausstellung gezeigt – wolltest Du da Plätze
und Orte in National City schöner erscheinen lassen, indem Du
sie fotografiert und dann auf Leinwand gezogen hast?

JB: Nein. Als ich die ersten Arbeiten machte, kam ich mir vor
wie ein Kriegskorrespondent. Ich mußte mich selbst finden.
Das war mein Wille zu der Zeit.

MC: But you've done some recently. There are the newer ones
in this show – National City revisited.

JB: Yeah, and the new ones could be less successful because
I was less innocent. Back then I thought of them like the things
you'd see in the window of a bad real estate office, not
doctored up in any way. Even the text, I just wanted the infor-
mation. I couldn't get those things shown for a long time. They
were just so ordinary. What was there to redeem them?

MC: What changed?

JB: Taste has changed.

MC: And now they are some of your best loved works.

JB: (*surprised*) I know! There's a lesson there I guess. It's my
latest aphorism that I've come up with. We do new work so the
old work will sell. Isn't it true? I guess what I'm saying is that
if you're a decent artist you're a little bit ahead of the game.

MC: Do you generally discard things that you know are
beautiful?

JB: I think so. I feel that beauty doesn't need any help from
me. It's doing fine on its own.

MC: Aber du hast ja jetzt wieder Bilder zu diesem Thema gemacht. Sie sind hier in der Ausstellung – National City revisited.

JB: Ja, und die neuen Arbeiten werden wahrscheinlich weniger erfolgreich sein, weil ich weniger unschuldig war, als ich sie machte. Bei der ersten Serie wollte ich die Bilder so haben wie Fotos aus einem wirklich scheußlichen Immobilienladen. In keiner Weise aufgeputzt. Auch der Text sollte so sein. Ich wollte nur reine Information. Ich konnte mich lange Zeit nicht entschließen, die Arbeiten zu zeigen. Sie waren so gewöhnlich. Warum sehen sie jetzt bloß so anders aus?

MC: Ja, was hat sich geändert?

JB: Der Geschmack hat sich geändert.

MC: Und nun gehören sie zu den Arbeiten von Dir, die am meisten geliebt werden.

JB: (*überrascht*) Ich weiß! Ich glaube, das lehrt uns eine Lektion. Das ist mein neuester Aphorismus. Wir müssen neue Werke schaffen, damit die alten sich verkaufen lassen. Ist das

MC: Since you mentioned Wittgenstein earlier… Apparently, he said if people didn't do stupid things nothing intelligent would ever get done.

JB: I like that one. (*artist signals two thumbs up*) I agree with that 100%.

MC: How do you avoid becoming self-conscious? It's hard to do a silly thing when you already know it's a silly thing.

JB: Well, given the choice between an elegant idea and a dumb idea I'm going to go with the dumb idea. Dumb, for me, is a good word. I once said at an opening or party that I liked Doug Huebler's photographs because they were dumb. Someone there was appalled, thinking I was insulting Doug and I said, no, they're dumb, they're mute and stupid and not about parading some sort of virtuosity. It's back to simplicity again.

MC: It's not in this show but, my favorite title of yours is, "Size/Shape (Destiny)", 1988–89. It seems to summarize a lot of your work. If I understand it correctly, you mean to say size/shape is destiny but since size and shape are not necessarily fixed neither is destiny. I read your work as offering a variety of situations where destiny is transformed. In the case of that work, a person's destiny is being changed by getting a nose job.

JB: A lot of my work is about making choices and of course choices effect destiny. As soon as you're doing one thing

SIZE / SHAPE (DESTINY)
1988–89
Schwarzweißfotografien/
Black and white photographs
198 x 259 cm/78 x 102 inches
Private collection, Courtesy Sonnabend
Gallery, New York

nicht wahr? Ich will damit sagen, ein guter Künstler ist seiner Zeit immer ein bißchen voraus.

MC: Schließt Du generell Dinge aus, von denen Du weißt, daß sie schön sind?

JB: Ich glaube schon. Ich denke, die Schönheit braucht mich nicht. Sie braucht keine Hilfe, sie kommt allein zurecht.

MC: Apropos Wittgenstein, den Du erwähnt hat. Er hat einmal gesagt, wenn die Menschen nichts Dummes täten, würde nie etwas Intelligentes geschehen.

JB: Das gefällt mir. (*Er streckt zwei Daumen in die Höhe.*) Da stimme ich hundertprozentig zu.

MC: Wie vermeidest Du, daß Du Dir beim Arbeiten zusiehst? Es ist doch sehr schwierig, etwas Dummes zu tun, wenn man von vornherein weiß, daß es dumm ist.

JB: Nun, vor die Wahl gestellt, einer eleganten oder einer dummen Idee zu folgen, würde ich mich immer für die dumme entscheiden. Ich habe einmal bei einer Vernissage oder auf einer Party gesagt, daß ich Doug Hueblers Fotografien mag, weil sie so dumm sind. Irgendjemand fand das entsetzlich; er dachte, ich wollte Doug beleidigen, und ich sagte ihm: Nein, sie sind schlicht, sie sind stumm, sie sind dumm. Sie wollen keine Virtuosität ausstellen. Sie sind ein Plädoyer für die Einfachheit.

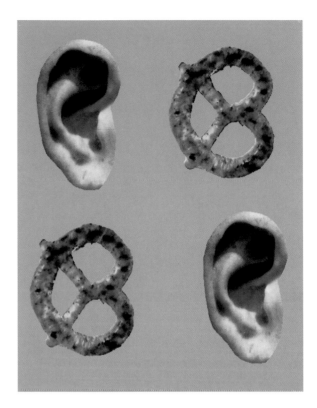

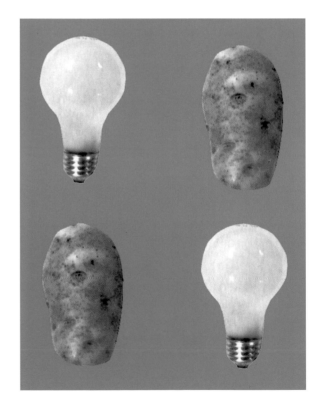

Details of WALLPAPER:
PRETZEL AND EAR, 1997–98
POTATO AND LIGHTBULB, 1997–98

Tapeten, Maße variabel/
Wallpapers, dimensions vary

MC: Einer meiner Lieblingstitel – das Bild ist nicht in der Ausstellung – heißt "Size/Shape Destiny", 1988–89. Für mich faßt er viel von dem zusammen, was Deine Arbeit ausmacht. Wenn ich ihn richtig verstehe, willst Du sagen, Größe und Form sind Schicksal, aber da Größe und Form nicht notwendigerweise feste Größen sind, steht auch das Schicksal nicht fest. Für mich zeigt Deine künstlerische Arbeit eine Vielzahl von Situationen, in denen das Schicksal verändert wird. In dieser speziellen Arbeit verändert sich das Schicksal eines Menschen durch eine neue Nase.

JB: Viele meiner Arbeiten haben die Möglichkeit einer Wahl zum Thema und klar, wie ich wähle, das beeinflußt mein Schicksal. Sobald Du Dich für eines entscheidest, schließt du ein anderes aus. So bestimmst Du in jedem Augenblick über Dein Schicksal – entweder bewußt oder unbewußt.
Die Arbeit, die Du erwähnst, spielt auf Freud an, der behauptet, Anatomie sei Schicksal. Ich fand das immer irgendwie lustig. Was er meiner Meinung damit sagen will, ist wohl, daß schöne Menschen im Leben besser zurecht kommen als andere, die nach konventioneller Vorstellung nicht so schön sind.

MC: Aber bietet die Kunst nicht einen Ausweg? Ein geschickter Chirurg kann die Anatomie verändern. In einem Gemälde oder einer Fotografie verändern oder manipulieren wir auch das Erscheinungsbild.

JB: Genau.

MC: "Lamps and Plants" ist die Version eines früheren Werkes, die Du im Witte de With in Rotterdam gezeigt hast – eine Installation, bei der Du mit Michael Shamberg zusammen gearbeitet hast. Damals hieß sie "RMS W VU Wallpaper, Lamps and Plants (New)". Der Titel klingt, als habe ein Vermieter eine Annonce in der Zeitung aufgegeben. War das Deine Absicht?

JB: Ja, zuerst hatte ich die Befürchtung, daß der Titel in der Übersetzung nicht verstanden würde. Aber sie haben dort

you're not doing something else. So, every moment you're shaping your destiny either purposefully or not.
In that piece, I'm making an allusion to Freud's comment that anatomy is destiny. I always thought that was kind of amusing. I think what he was getting at at was, beautiful people get ahead better than people who are not conventionally beautiful.

MC: But isn't art the way out of that? A skilled plastic surgeon can alter anatomy. In a painting or in a photograph we change or manipulate appearance.

JB: Exactly.

MC: The piece, "Lamps and Plants", is a version of work you did at the Witte de With in Rotterdam – an installation you did with Michael Shamberg. There it was titled, "RMS W VU Wallpaper, Lamps, and Plants (New)". The title sounds like an ad a landlord would place in the newspaper. Was that your thinking?

JB: Yeah. I was worried at first that it didn't translate but then apparently they do have ads like that. Also Shamberg wanted to have different rooms, a bedroom, a living room and so on, for the video aspect of the show.
It was supposed to be a domestic setting so, I decided to do wallpaper. Then I thought something should go on the wallpaper. I had been working with lamps a lot and I had just had started photographing potted plants and then, wonders of wonders, I figured out that flower pots look a lot like lamp shades. Wow! What a revelation. (laughs) Then nature/culture and on and on, all these kind of oppositions.
I was trying to think of a title for it all and started thinking about these ads – Rooms With View etc. and how they get abbreviated. Basically, the Witte de With was rooms with windows. I didn't want to glamorize the situation I wanted to keep it really very simple so, that's how I presented it.

solche Anzeigen. Außerdem wollte Shamberg für das Video verschiedene Räume haben, ein Schlafzimmer, ein Wohnzimmer und so weiter.

Es sollte eine Wohnsituation sein, daher entschied ich mich für die Tapete. Dann dachte ich, da sollte etwas drauf. Ich hatte schon öfter mit Lampen gearbeitet und gerade angefangen, Topfpflanzen zu fotografieren. Und dann, Wunder über Wunder, stellte ich mir vor, daß Blumentöpfe wie Lampenschirme aussehen. Was für eine Offenbarung! (*lacht*) Damit hatte ich alle möglichen Gegensatzpaare, Natur und Kultur, na ja und so weiter.

Ich strengte mich an, einen Titel für das Ganze zu suchen, und begann, an diese Anzeigen zu denken: Zimmer mit Aussicht etc. und an all die Abkürzungen dafür. Zimmer mit Aussicht, das war im Grunde das Witte de With. Ich wollte keine glamouröse, sondern eine ganz einfache Situation haben, und so habe ich sie auch dargestellt.

MC: Die Tapete hat lustige Muster, unter anderem Kartoffeln und Glühbirnen.

JB: (*lacht*) Für mich stand die Glühbirne für Erleuchtung, dafür, eine Idee zu haben, und die Kartoffel, na ja, für das Erdhafte, für jemanden auch, der etwas dösig ist. Ich glaube, das war nicht so toll.

MC: Und wofür standen die Pizza mit dem Uhrenmuster? Die Nase und das Popcorn, die Brezeln und Augen?

JB: Eine Uhr ist rund wie eine Pizza. Die Pizza symbolisiert ja auch jemanden, der nicht sehr helle ist, und die Uhr mahnt, daß wir mit unserer Zeit klug umgehen sollen, so etwas in der Art. Und dann hat das alles mit der Umgebung zu tun. Die Leute schauen fern und essen Pizza, Brezeln und Popcorn – sie rühren sich nicht von der Stelle, sind 'couch potatoes'. Einerseits ist da all dieses dösige Zeug, und andererseits gibt es das Bewußtsein, die Sinne, das Hören, Schmecken und so weiter.

MC: The wallpaper has very funny patterns – potatoes and light bulbs for example.

JB: (*laughs*) I was thinking that the light bulb is an idea and the potato is rather cloddish – not too inspired. What would it mean if someone had a potato over their head. Not very smart I guess.

MC: What's the idea of the pizza and clock pattern? Also the nose and popcorn, pretzels and ears?

JB: A clock is sliced the same way as the pizza. Pizza is a symbol of dumbness and the clock symbolizes what we aspire to – a good use of time, something like that. Also it's a lot about that environment; people watching TV. So, you're eating pizza, pretzels, popcorn that sort of thing – couch potatoes. So on one hand, you have all the dumb cloddish stuff and on the other hand you have the life of the mind, the senses, the sense of hearing, smell and so on.

MC: The more noble aspirations?

JB: Something like that.

MC: But neither is given priority. The noble isn't given more weight than the cloddish.

JB: No, I'm not assigning value. I'm just saying when something is happening here something else is happening over there. Who am I to say what's important?

MC: You seem very mindful of formal similarities. For example you seem intrigued that a pretzel is similar to an ear. It also has chambers and is roughly the same shape. Is more to be made of that? Are you saying, formal similarities in things are significant or are potentially significant if we consider them?

JB: They mean, yeah sure.

MC: Das edlere Streben.

JB: So etwa.

MC: Aber keinem von beiden wird der Vorzug gegeben. Das Edle bekommt nicht mehr Gewicht als das Depperte.

JB: Nein, ich will doch nicht moralisieren. Ich sage nur, wenn hier etwas geschieht, geschieht dort etwas anderes. Wer bin ich denn, um zu sagen, was wirklich wichtig ist.

MC: Du scheinst sehr genau auf formale Ähnlichkeiten zu achten. Du siehst, daß eine Brezel Ähnlichkeit mit einem Ohr hat. Sie ist auch ähnlich unterteilt und geformt. Gibt es dazu noch mehr zu sagen? Willst du darauf hinaus, daß formale Ähnlichkeiten zwischen Dingen bedeutsam oder potentiell bedeutsam sind, wenn wir sie anschauen?

JB: Sicher haben sie Bedeutung.

MC: Das Etikett eines Formalisten würde Dich nicht stören?

JB: Jemand hat mich einmal so genannt, und ich glaube, es war abwertend gemeint. Aber ich habe es doch irgendwie gemocht, weil mir Form viel bedeutet. Bevor ich mit Photoshop gearbeitet habe, bin ich über meine Aufnahmen mit Ölfarbe gegangen und habe die dunklen und hellen Partien verändert. Ich wollte wissen, wie das formal aussieht. Aber wenn es sich um Fotografien handelt, dann denken die Leute irgendwie nicht so darüber nach als wenn es um Gemälde geht.

MC: Das Etikett stört Dich also nicht? Obwohl es sehr modisch ist.

JB: Wirklich? Ein Formalist genannt zu werden?

MC: Wußtest Du das nicht?

JB: Nein, ich dachte, es sei beleidigend.

MC: Would you be comfortable with the label formalist?

JB: Somebody called me that once and I think it was supposed to be derogatory, though I kind of liked it because I do think about that a lot. Before Photoshop, I would go in with oil paints and alter darks and lights only thinking how it looked formally. But somehow when it's in a photograph people don't think about it as much as when it's in a painting.

MC: So you're comfortable with the label? You know it's very fashionable.

JB: Really? To be called a formalist?

MC: Didn't you know?

JB: No, I thought it was being used as an insult.

MC: In terms of the way you structure your work, you've generally resisted the use of a single image.

JB: I can't seem to do it. I did do it when I was a painter because you have a single canvas. I suppose I did a couple diptychs or triptychs in painting and that was about it. What got me away from the single image was movies. I began seeing paintings in a row in a museum as being like frames in a movie. So I got to fantasizing… what was the frame before this van Gogh painting and what was the frame after? If you had a wide angle shot of the painting what would it look like? I started thinking about painting in cinegraphic terms. I had a feeling that one image was too emblematic of the truth. One image meaning, it is *this* way.

MC: The single image is iconic?

JB: Yeah. The frame before it is rejected the frame after it is rejected and this frame is the one that is chosen. I am always curious why things are rejected and why one thing is chosen.

MC: Was die Struktur Deiner Arbeit angeht, so hast Du es im Allgemeinen vermieden, Dich auf nur ein einzelnes Bild zu konzentrieren.

JB: Irgendwie kann ich das nicht. Als Maler war das anders. Da habe ich es getan, weil man nur eine Leinwand hat. Gut, ich habe auch einige Diptychen und Triptychen gemalt, aber das war's dann. Was mich weggebracht hat vom Einzelbild, war der Film. Plötzlich begann ich, Gemälde im Museum in Serie zu sehen wie die einzelnen Bilder einer filmischen Sequenz. Ich stellte mir vor, welches Bild vor einem van Gogh Gemälde kommen sollte und welches danach. Ich dachte darüber nach, wie das Bild durch ein Weitwinkelobjektiv aussehen würde. Ich begriff das Malen plötzlich unter filmischen Kategorien. Und ich kam zu der Überzeugung, ein einzelnes Bild sei zu emblematisch für die Wahrheit. Ein einzelnes Bild bedeutet immer: so ist es.

MC: Das Einzelbild als Ikone?

MC: In the Goya Series you have an image and a simple text: this AND that.

JB: I suppose in a very reductive way it's emblematic of the way I could never have this feeling of totality, of wholeness. That there is always something else that will complete the picture somehow.

MC: In that series you have a work titled, "Strange". There is a photo of an ordinary book and the word strange. What is strange?

JB: I like that word a lot as an antonym to the familar. I think art should make things look strange. If a book is good it should make things strange but I like the play of it because in this case the book looks so ordinary. It doesn't look strange at all. It's not even worth noticing. Why photograph a book?

GOYA SERIES:
STRANGE
1997
Ink-jet auf Leinwand/
Ink jet on canvas
190 x 152 cm/
75 x 60 inches
Private collection,
Switzerland

GOYA SERIES:
THESE TOO
1997
Ink-jet auf Leinwand/
Ink jet on canvas
190 x 152 cm/
75 x 60 inches
Collection Per Ovin

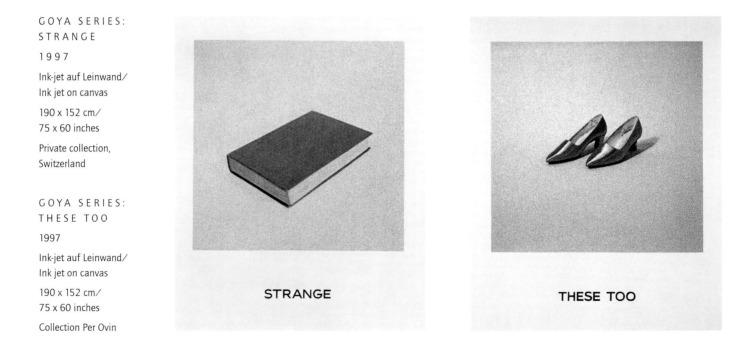

STRANGE · THESE TOO

JB: Ja. Ein Bild wird gewählt. Das Bild davor wird verworfen, das Bild danach wird verworfen. Ich frage mich immer, warum Dinge verworfen werden und warum gerade ein bestimmtes Ding gewählt wird.

MC: In Deiner Goya-Serie sieht man das Bild und einen einfachen Text: dies *und* das.

JB: Ich glaube, ganz zurückgenommen, sind sie emblematisch dafür, daß ich nie das Gefühl der Totalität, eines Ganzen, haben könnte. Daß es da immer noch etwas anderes gibt, um das Bild komplett zu machen.

MC: In der Serie gibt es auch eine Arbeit mit dem Titel "Strange". Man sieht das Foto eines ganz gewöhnlichen Buches und das Wort 'strange' (seltsam). Was ist seltsam?

JB: Ich mag das Seltsame in Opposition zum Gewohnten. Ich finde, die Kunst sollte die Dinge fremd und merkwürdig erscheinen lassen. Bei der erwähnten Arbeit gefällt mir die Wechselwirkung zwischen Bild und Wort. Das Buch sieht so gewöhnlich aus, überhaupt nicht merkwürdig. Man möchte keinen Blick daran verschwenden. Warum sollte man dieses Buch fotografieren?

MC: Die Arbeit "There Isn't Time" zeigt ein ganz normales Blumenarrangement.

JB: Sie ist Teil der Vanitas-Serie, die ich vor langer Zeit machte. Sie handelt vom verfließenden Leben, und Blumen in einer Vase schienen mir dafür ein guter Ausdruck. Aber man kann die Arbeit auch ganz einfach so lesen: manchmal schickt man Blumen, um etwas wieder gutzumachen, und oft ist es dann schon zu spät.

MC: In der Arbeit "These Too" sehen die Schuhe aus wie Dorothys rote Slipper im *Wizard of Oz*.

MC: "There Isn't Time", shows a common flower arrangement.

JB: I think this piece came out of the Vanitas Series I did way back, which was about life being fleeting and flowers in a vase somehow representing that. It can also be read as when someone sends flowers it is usually about trying to repair something and often being too late.

MC: In the piece, "These Too", the shoes look like Dorothy's ruby slippers in the *Wizard of Oz*.

JB: Yeah, "fuck me" shoes. Also I wanted some idea of loss like, "Oh no, not the shoes too!" Maybe the work preceding this we could imaging being something like, "Everything goes" and then saying, "These too." It's almost like an edict. But they're empty and that's sad for some reason. Maybe it's just me.

MC: I often see one shoe abandoned on the road. It does seem really sad.

JB: Shoes seem to be the last emblem or vestige of some person. If you think from the top down the shoes are the last thing and then the person's gone. So it's almost like trying to hang on to life.

MC: Peter Schjeldahl said Goya used language to expose the inadequacy of language and says you do the same for images. Do you agree with that? Do you agree you use images to show the inadequacy of images? And if so, how are images inadequate?

JB: Sometimes I think images can say more than words. Maybe I use images when I am at a lack for words. But then sometimes I change my mind and I think, no, words are the most abstract because they are these things we invented. We can attach them to whatever we want.

Nothing, Trim——said my uncle Toby, musing——

Whilst a man is free——cried the Corporal, giving a flourish with his stick thus——

JM: Ja, "Fuck me"-Schuhe. Außerdem sollten sie Verlustangst ausdrücken à la "Oh nein, nicht auch noch die Schuhe". Die vorangehende Arbeit hatte ungefähr die Idee zum Ausdruck gebracht: "Alles geht vorbei", und dann folgt "These Too" (Diese auch). Der Titel ist fast wie eine Verkündigung. Aber die Schuhe sind herrenlos und das ist irgendwie traurig. Vielleicht stellen sie mich dar.

MC: Manchmal sehe ich mitten auf der Straße einen einsamen Schuh, und das ist wirklich sehr traurig.

JB: Schuhe scheinen die letzte Spur oder ein Emblem des Menschen zu sein. Stellt man sich den Menschen vom Kopf bis zu den Füßen vor, sind Schuhe das Letzte, was man sieht, und dann verschwindet die Person. Es ist, als wolle man mit ihrer Hilfe am Leben festhalten.

MC: Peter Schjeldahl hat geschrieben, daß Goya mit Hilfe der Sprache die Unzulänglichkeit der Sprache dargestellt hat und daß Du dasselbe mit Bildern machst. Stimmst Du dem zu? Stellst Du mit Hilfe von Bildern die Unzulänglichkeit der Bilder dar? Und was ist ein unzulängliches Bild?

JB: Manchmal denke ich, Bilder wissen mehr zu sagen als Worte. Vielleicht benutze ich Bilder, wenn mir die Worte fehlen. Aber dann denke ich wieder, daß Wörter doch ganz abstrakt sind, daß wir sie erfunden haben und mit allem verbinden können, was wir wollen.

MC: Oft sieht es so aus, daß Du nicht wählst, sondern Dich in Deiner Arbeit für eine dritte Möglichkeit entscheidest. Du

MC: Or it seems a lot of times you've taken the third option, saying, why choose? Use a word where it's suitable use an image where that seems more effective.

JB: Or use both. I guess it's fundamental to my work that I tend to think of words as substitutes for photographs. I can never seem to figure out what one does that the other doesn't do, so it propels me, this kind of bafflement.

MC: And you've liked writers who will use an illustration – Laurence Sterne, for example. He has illustrations in *Tristram Shandy* and you did illustrations for an edition of that novel.

JB: When I read *Tristram Shandy* I thought, my God this guy is like me. He would just lapse one form into the other. Why

benutzt je nachdem, wie es passend erscheint, entweder ein Wort oder ein Bild.

JB: Oder beides zusammen. Ich glaube, es ist ganz wichtig für mein Werk, daß für mich Wörter Stellvertreter für Fotografien sind. Mir ist nie bis ins Letzte klar, was das eine kann, was das andere nicht kann, und diese Verwirrung treibt mich an.

MC: Und Du liebst Schriftsteller, die mit Illustrationen gearbeitet haben – zum Beispiel Laurence Sterne. In seinem Roman *Tristram Shandy* benutzt er welche, und für eine Neuausgabe des Buches hast Du die Illustrationen gemacht.

JB: Als ich den *Tristram Shandy* las, dachte ich, mein Gott, der Mann ist wie Du. Der springt von einer Form zur anderen. Warum auch nicht? Es scheint so normal zu sein, daß man sich wundert, warum es nicht öfter passiert. Ich denke, erst in der Moderne haben wir zwischen beiden Formen unterschieden.

MC: In der Goya-Serie benutzt Du Sentenzen aus Titeln von Goya und eigene. Kehrst Du mit diesen Arbeiten zu Deiner ursprünglichen Strategie zurück und gibst den Menschen, was sie verstehen – das geschriebene Wort und das fotografische Bild?

JB: Ich glaube schon, aber das war nicht mein eigentliches Motiv. Es hatte mehr mit Zeit zu tun und was für ein Luxus das ist. Wenn man als Künstler anfängt, möchte man so viele Felder wie möglich beackern. Das ist eine Frage des Territoriums. Aber man hat gar nicht die Zeit, all diese Felder überhaupt kennenzulernen.
Ich dachte bei dieser Serie noch einmal über eine Arbeit nach, bei der ich einen Titel von Goya verwandt hatte, "This is Not to Be Looked at" (1966–68). Ich war damals der Meinung, ich sollte noch einmal in diesen theoretischen Schatzkammern nachschauen, um zu sehen, was ich zu Tage fördern könnte. Die Arbeit hatte mich nie ganz in Ruhe gelassen. So kam es, daß ich mir die Goya-Titel noch einmal vornahm.

not? It seems so normal you would expect it to happen more often. I think it's us who have made the distinction between the two forms.

MC: In the Goya Series, you use text taken from Goya titles and some of your own. Would you say those works return to your original strategy that you described as giving people what they understand – the written word and a photograph?

JB: I suppose, but that wasn't my prime motivation. It was more about having the luxury of time. The way I described it to myself is when you are starting out as an artist you want to piss on as many trees as you possibly can. It's about territory. You don't really have time to get to know each tree.
I started thinking again about that one piece I did using a Goya title ("This Is Not To Be Looked At", 1966–68) and thought at this point in my life I can go back and reopen some of those theoretical gold mines and see if there is anything else to be mined. That piece had always sort of gnawed at me. So I thought I'd go back and reexamine the Goya titles again.
I liked the Goya titles because they were so non-specific and they said so much. I thought without the etching they could stand on their own – they're so beautiful. So then I decided to go with it and make it a whole series. And then almost like thinking of Goya's titles as training wheels I decided to do some of my own in the spirit of Goya.

MC: In the Elbow Series, all the pieces have three components, a photographic image of plant life, text printed with the name of an animal and a human face taken from a Goya painting. I like that you didn't show the animals – rather you used their names (i.e., yak, emu) because we don't normally have the chance to see animals roaming around. We never see them except in images or maybe in a zoo. Was that the idea?

JB: Yeah, and I mean it's being playful. I was trying to exhaust all the three-letter animals in Roget's Thesaurus.

Ich mochte diese Titel, weil sie so gar nicht spezifisch für etwas sind und dabei soviel aussagen. Ich fand, sie könnten auch sehr gut für sich stehen ohne die dazugehörigen Radierungen. Sie sind wirklich schön. Das war der Punkt, an dem ich den Entschluß faßte, sie für eine ganze Serie zu verwenden. Und während ich mich an Goyas Titeln abarbeitete, kam mir die Idee, noch eigene in seinem Geist hinzuzufügen.

MC: In der Elbow-Serie bestehen die Arbeiten aus drei Teilen, dem Bild einer Pflanze, dem Namen eines Tieres und einem Gesicht aus einem Gemälde von Goya. Mir gefiel, daß Du die Tiere nicht gezeigt hast, sondern nur ihre Namen genannt hast, zum Beispiel Yak, Emu, etc., denn normalerweise sehen wir solche Tiere nie, es sei denn auf Bildern oder im Zoo. War das die Idee dahinter?

JB: Ja, und dann war es natürlich auch sehr spielerisch gemeint. Ich wollte die Namen aller Tiere mit nur drei Buchstaben aus Rogets "Thesaurus" rausfischen.

MC: Warum mit drei Buchstaben?

JB: (*er zeigt auf die drei Teile der Arbeit*) Eins, zwei, drei.

MC: Ah ja, natürlich.

JB: Ich bin ein Formalist, Du erinnerst Dich?

MC: Why animals with three-letter names?

JB: (*pointing to the three components of the work*) Well, one, two, three.

MC: Oh, of course.

JB: I'm a formalist, remember?

MC: At least lately, you use a lot of animals in your work.

JB: Yeah, I use a lot of animals because I want them to have parity with humans in some way. I always remember this phrase of Bob Smithson saying, even flies should have art. I use a lot of crowd scenes too, for similar reasons, because it seems art is always about one or two people. Why are there rarely crowds? Is it that they're too scary or too corrosive of our own ego?

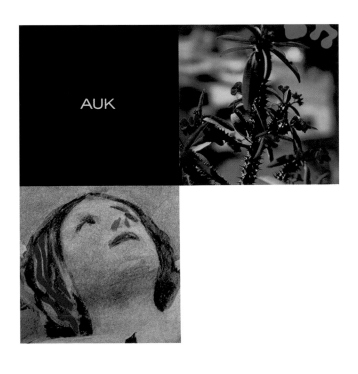

ELBOW SERIES: AUK

1999

Ink-jet auf Leinwand, Folio D Prozeß auf Vinyl, handgeschriebener Text und Acrylfarbe/Ink-jet on canvas, Folio D process on vinyl, acrylic

213 x 213 cm/84 x 84 inches

Courtesy Sonnabend Gallery, New York, and Massimo Martino Fine Arts & Projects, Mendrisio

MC: In letzter Zeit benutzt Du häufig Tiere in Deiner Arbeit.

JB: Ja, ich benutze häufig Tiere, weil ich irgendwie ein Gleichgewicht anstrebe zwischen Menschen und Tieren. Ich denke oft an die Bemerkung von Bob Smithson, der gesagt hat, auch die Fliegen sollten Kunst haben. Aus ähnlichen Gründen zeige ich auch häufig Massenszenen. Man muß ja den Eindruck haben, Kunst handele nur von einem oder zwei Menschen. Warum werden so selten Massen gezeigt? Attackieren und untergraben sie vielleicht unsere Ego-Vorstellungen?

MC: Ich mag auch, daß die Tiere so unspezifisch aussehen. Ein Yak ist ein Ochse mit langen Haaren. Ein Gnu ist eine Antilope mit dem Schädel eines Ochsen. Ein Emu ist ein rennender Vogel, der nicht fliegen kann. Ein Alk ist eine Art fliegender Pinguin.

JB: Ich mag diese Deutung, obwohl ich nicht daran gedacht habe.

MC: Diese Tiere sind perfekte Baldessari-Charaktere. Zwei Dinge in einem. Es sind Tiere, die ihren eigenen Widerspruch verkörpern.

JB: (lacht) Das gefällt mir – schreib' das!

MC: Die Pflanzen sind auch ganz ungewöhnlich. Wenn ich sie mit den Pflanzen von "Lamps and Plants" vergleiche, die sanft und gutartig sind, Topfpflanzen, archetypische Pflanzen, scheinen die hier ebenso viele Dornen wie Blüten zu haben. Von denen geht mindestens so viel Unangenehmes wie Angenehmes aus.

JB: Ja, es gibt Pflanzen, die ich genau aus diesem Grund nicht nehme, weil sie zu angenehm sind. Ich denke darüber nach, welche Pflanzen ich nicht genommen habe. Normalerweise verwerfe ich Dinge, die zu schön sind. Man kann den ganzen Tag darüber nachdenken, warum man das eine wählt und das andere nicht.

MC: I also like that the animals themselves have a contingent quality. A yak is an ox with long hair. A gnu is an antelope with an ox head. An emu is a running bird who can't fly. An auk is a kind of flying penguin.

JB: I love this reasoning. It wasn't mine.

MC: The animals you've chosen seem like perfect Baldessarian characters, they are two things in one. They are animals that form their own paradox.

JB: I love that – print it. (laughs)

MC: The plants are all unusual, too. If I compare them to the plants in "Lamps and Plants", those plants seem more benign – archetypal plants, potted plants. These seem to have at least as many thorns as flowers. They seem capable of at least as much misery as comfort.

JB: Obviously, there are plants I would reject for this. I am trying to remember the plants I rejected. Ones that were too pretty, I usually reject things that are too pretty. You can spend all day trying to figure out why you scotched one and chose another.

MC: All the pieces have a figure in them taken from a Goya painting. Why Goya? Could you have used any artwork?

JB: Yeah, any artwork could have worked. I had all these shots of Goya heads and I liked them because he was pulling at our heart strings – a figure looking beatifically up, this guy aspiring to something, the other one being penitent… It's something I'm interested in – how different emotional states can be portrayed via the mask of the face.

MC: They all seem reluctant. None of them are looking right at you.

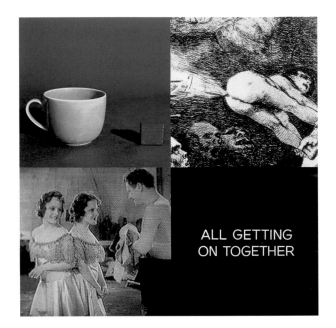

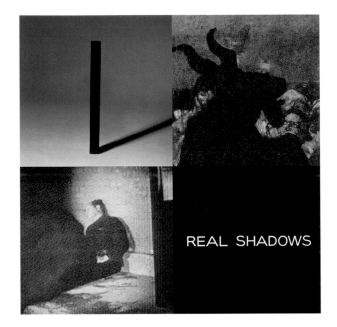

TETRAD SERIES: ALL GETTING ALONG TOGETHER

1999

Digitaldruck, handgeschriebener Text, Acrylfarbe auf Leinwand/
Digital printing, hand lettering, and acrylic paint on canvas

239 x 239 cm/94 x 94 inches

Courtesy Marian Goodman Gallery, New York, Paris

TETRAD SERIES: REAL SHADOWS

1999

Digitaldruck, handgeschriebener Text, Acrylfarbe auf Leinwand/
Digital printing, hand lettering, and acrylic paint on canvas

239 x 239 cm/94 x 94 inches

Collection of Craig and Ivelin Robins, Miami Beach, FL
Courtesy Marian Goodman Gallery, New York, Paris

MC: In allen Arbeiten gibt es eine Figur aus einem Goya-Gemälde. Warum Goya? Hätten es nicht auch andere Bilder sein können?

JB: Ja, es hätten auch andere Bilder sein können. Aber ich hatte nun einmal all diese Aufnahmen von Köpfen aus Goya-Gemälden, und ich mochte sie. Sie sind herzbewegend! Wie eine Figur da verzückt in die Höhe blickt, eine andere sich nach etwas sehnt und wieder eine andere etwas bereut. Das interessiert mich. Wie unterschiedliche Gefühlszustände über den Gesichtsausdruck gezeigt werden.

MC: Sie wirken alle so zurückhaltend. Niemand von ihnen schaut den Betrachter direkt an.

JB: That's right. Also, they are spectators in some way. They are involved in the looking. While we're looking at them, they're looking at something.

MC: That's back to the title of the show, isn't it?

JB: Yeah.

MC: In the Tetrad Series, all the works are divided into four images. How was that decided?

JB: It was very simply four ways of understanding what's around me: through literature, through art, through objects in the world, through film. Which are four of many, but certainly four that affect me.

JB: Das stimmt. In gewisser Weise sind sie selbst Betrachter. Sie sind mit Schauen beschäftigt. Während wir sie anschauen, schauen sie etwas anderes an.

MC: Das bringt uns zurück zum Titel der Ausstellung, nicht wahr?

JB: Ja.

MC: In der Tetrad-Serie besteht jede Arbeit aus vier Bildern. Wie kam es dazu?

JB: Ganz einfach: Es sind vier verschiedene Arten, um zu verstehen, was um mich herum vorgeht. Durch Literatur, durch Kunst, durch Dinge und durch den Film. Das sind nur vier von vielen, aber in jedem Fall vier, die mich berühren.

MC: Die Texte dieser Serie stammen von dem portugiesischen Schriftsteller Fernando Pessoa. Der Held in Pessoas "Buch der Unruhe" ist ein sehr depressiver Mann, der eine unglaublich langweilige Arbeit hat. Er verläßt nie sein kleines Viertel in Lissabon, und doch inspiriert es ihn zu seiner Philosophie. Ich bin versucht, das Buch als Metapher zu lesen für National City, wo Du aufgewachsen bist.

JB: So sehe ich das auch. Für Pessoas Protagonisten sind die ganz gewöhnlichen Dinge um ihn herum äußerst interessant. Und er erwartete nicht, daß das irgendjemanden sonst interessiert. So ähnlich habe ich gefühlt während der Arbeit an der "National City"-Serie.

MC: Kannst Du irgendeine der Arbeiten näher beschreiben?

JB: Zum Beispiel "All Getting On Together". Im Vergleich zu anderen ist sie scheinbar sehr einfach zu verstehen. Sie handelt vom Anderssein, aber weil die Arbeiten alle eng zusammenhängen, kommen sie auch miteinander aus (all getting on together).

MC: The text in the series comes from the Portuguese writer, Fernando Pessoa. The main character in Pessoa's *Book of Disquiet* is this very depressed man who has an incredibly dull job. He never leaves a small area in Lisbon, and yet he writes this whole philosophy from that spot. I am tempted to read the novel as being a metaphor for National City, where you were raised.

JB: Yes, I was going to say that too. He was seeing the ordinary things around him as interesting. Sort of like I felt when I did those National City pieces. He didn't expect anyone else to be interested.

MC: Can you describe one of the works specifically?

JB: This one, "All Getting On Together", seems like an easy read compared to some of the other ones. This one is about difference but because they're all in the same place they're getting along together.
I guess I am doing it by degrees. Here, (*pointing to a movie still of siamese twins*) they would have to get along together and here, (*a Goya etching showing a flatulent person turning their backside to the faces of three other figures*) I am being rather ironic. They are forced together, they're all downwind from a gigantic fart. This, (*a photograph of a tea cup and wood block*), is the most far-fetched. Who knows if they can get on together, but they are sharing the same space.

MC: This is titled "Real Shadows". Shadows or shadow figures appear a lot in yor work.

JB: Why is that? I guess because darkness is ominous and threatening and I think art tends to be constructed on the premise that we inhabit a world of light rather than dark. I mean painters work on white canvases, there is white photographic paper and so on. I often wonder what kind of art we would have if we could only buy black canvas or black paper. For me black is scary, in a childlike way, but it seems to fit into my idea that stability is temporary.

Ich glaube, ich behandele das Thema schrittweise. Hier (*er weist auf einen Filmstill, der siamesische Zwillinge zeigt*) – sie müssen miteinander auskommen, und da (*er deutet auf eine Goya-Radierung, auf der eine Person mit einer Flatulenz drei anderen Figuren den Rücken zuwendet*) bin ich sehr ironisch. Sie werden alle zusammengehalten und niedergezwungen durch einen gigantischen Furz. Dort (*man sieht die Fotografie einer Teetasse und eines Holzblocks*) ist das sehr weit hergeholt. Wer weiß, ob sie miteinander auskommen, aber immerhin, sie teilen sich denselben Raum.

MC: Diese Arbeit heißt "Real Shadows". Schatten oder Schattenfiguren spielen eine große Rolle in Deiner Arbeit.

JB: Du willst wissen, warum das so ist? Ich glaube, Dunkelheit ist unheilvoll und bedrohlich, und Kunst geht von der Voraussetzung aus, daß wir eher in einer hellen als in einer dunklen Welt leben. Maler malen auf weißer Leinwand, Fotopapier ist weiß und so weiter. Ich frage mich oft, was für eine Kunst wir wohl hätten, wenn wir nur schwarze Leinwände kaufen könnten oder schwarzes Papier. Für mich ist das Dunkle furchterregend, so wie sich Kinder im Dunklen fürchten. Es paßt zu meiner Vorstellung, daß es Sicherheit immer nur vorübergehend gibt.

MC: Es gibt viele Arbeiten von Dir, wo irgendetwas droht, ein Schatten oder eine Form …

JB: Genau, und Schatten sind darum spannend, weil sie alle möglichen Formen annehmen können, was die Menschen nicht können. Sie sind wie ein Widerpart der phantastischen Natur des Menschen. Fast wie ein paralleles Universum.

MC: Diese Arbeit aus dem Jahre 1992 hat einen sehr langen Titel, "Flying Saucer: Rainbow/Two Cyclists/Dog/Gorilla and Bananas/Chaotic Situation/Couple/Tortoise/Gunman (Fallen)".

MC: There are a lot of works where some thing threatens, a shadow or a shape…

JB: Exactly, and shadows are interesting in that they can take all kinds of shapes whereas people can't. It's like the more imaginative side of the person. It's almost like a parallel universe.

MC: This work has a very long title: "Flying Saucer: Rainbow/Two Cyclists/Dog/Gorilla and Bananas/Chaotic Situation/Couple/Tortoise/Gunman (Fallen)", 1992.

JB: I just wanted to get everything in there.

MC: Like a laundry list.

JB: I love lists, for one thing. I think a lot of my early work was almost syntactical in structure – this leads to this leads to this, like one word follows another. Here I was just looping it back on itself where this image modifies this and this is a modifier to this and so on. I think what defines me is that I think everything is connected in some way. As soon as you put two things together you get a story. I think I took it to extreme lengths here where the story curls back on itself. I love this idea of having a normal landscape but there is also this flying saucer which is a clue you have to include in order to understand the landscape.

MC: "Three Running Figures (One Splashed), Trash Cans, and Poles (With Large Blue Shape)", 1995. Is this piece narrative? It looks like a way to line up poles.

JB: Well, structurally it is, certainly. It's just some movie still, it could have been anything, any scene. The whole body of work was about slowing down the reading of something. If I had part of the image here, part of the image there you have to put it together in your mind's eye to get the whole image.

JB: Ich wollte alles, was in der Arbeit zu sehen ist, auch im Titel haben.

MC: Wie eine Wäscheliste.

JB: Ich liebe Listen. Ich glaube, viele meiner frühen Arbeiten sind wie ein Syntagma strukturiert. Dies führt zu dem und das wieder zu jenem, so wie in einem Satz ein Wort auf das andere folgt. In dieser Arbeit habe ich die Dinge wieder zu sich zurückgeführt, ein Bild beeinflußt das nächste und so weiter. Ich glaube, typisch für mich und meine Arbeit ist die Auffassung, daß alles irgendwie miteinander zusammenhängt. Sobald man zwei Dinge miteinander verbindet, hat man eine Geschichte. In dieser Arbeit erzähle ich eine sehr lange Geschichte, die wieder an den Anfang zurückkehrt. Ich liebe es, eine ganz normale Landschaft zu sehen, aber es braucht auch die fliegende Untertasse als Hinweis, um die Landschaft zu verstehen.

MC: Ist die Arbeit "Three Running Figures (One Splashed), Trash Cans, and Poles (With Large Blue Shape)" aus dem Jahre 1995 narrativ?

JB: Nun, von der Struktur her ganz sicher. Sie ist wie ein Filmstill und könnte vieles sein. Die ganze Arbeit dreht sich darum, ein Bild nicht zu schnell zu lesen. Wenn ein Teil des Bildes hier ist, und der andere Teil ist dort, dann mußt Du die Teile in Deinem Geist erst zusammensetzen, um das ganze Bild zu erhalten.
Was die Fotografie angeht, habe ich alles weggelassen bis auf ganz uninteressante Dinge, was ich ja auch schon früher so gemacht habe. Ich habe das Interessante rausgeworfen und das Uninteressante behalten. Bei dieser Arbeit habe ich die Szene in Form und Farbe übersetzt. Man sieht ein Gesicht und noch ein Gesicht und dann den Pfosten. Die Darstellung ist total reduziert.

MC: In diesen Arbeiten gibt es viel Weiß. In "Potatoes, Face (Smiling), Garbage Can, Four Shapes & Red and Green Lines" ist viel leerer Raum.

In terms of the photograph, I've taken out everything but the least interesting things about it which I've done before, subtract the interesting stuff and leave the uninteresting stuff. Here I've translated the scene into color and shape so this is somebody's face and this is somebody's face and this is the pole. This is a completely reductive statement of events.

MC: These works have a lot of white. In "Potatoes, Face (Smiling), Garbage Can, Four Shapes & Red and Green Lines", there is a lot of empty space.

JB: Everything is where it was in the original photograph. So that trash is where it was, the potatoes are where they were, the faces are where they were. The yellow was something, the green was something, the blue was something… everything is something that comes from the photograph. The white is just stuff I left out.
I've explained them as being how we experience the world. If you walk into a room and you have a lot of trash in your hand you're going to see the trash can and probably not see very much else or if you do, you might see a color some place or whatever and everything else might be avoided. The next day you might be hungry you might see the potatoes and everything that's not of interest will be avoided. So they're really lessons in seeing what's important. What things do we see first? Do we focus on what's of use or, for visual delight. What things are we just not interested in?

MC: The works are also very painterly. The editing system you describe is a good strategy for painting.

JB: I have always tried to make a hybrid form between painting and photography and this is probably as close as I've come.

MC: I liked this whole series. They're so weird. When I saw the show I didn't recognize them as your work immediately.

JB: Alles ist so wie in den originalen Fotografien. Der Müll ist, wo er war, und die Kartoffeln und die Gesichter. Das Gelb war so, das Grün war so und das Blau war so … alles ist so wie auf der Fotografie. Nur wo das Weiß ist, habe ich Dinge weggelassen.

Ich habe die Aufnahmen so bearbeitet, wie wir die Dinge wahrnehmen. Wenn man in einen Raum geht und einen Haufen Müll trägt, dann sieht man den Mülleimer und sonst wahrscheinlich nichts, oder aber man sieht noch irgendeine Form oder Farbe und alles andere wird ausgeblendet. Am nächsten Tag kommt man hungrig in denselben Raum und sieht nichts als die Kartoffeln, alles andere wird als nicht interessierend auch nicht wahrgenommen. Deshalb sind die Bilder Lektionen im Sehen. Wie man sieht, was man für wichtig hält. Welche Dinge sehen wir zuerst? Konzentrieren wir uns auf das Nützliche oder das optisch Lustvolle? Welche Dinge interessieren uns einfach nicht?

MC: Die Arbeiten sind sehr malerisch. Diese Wahrnehmungsfilter und Fokussierungen, die Du beschreibst, sind auch eine gute Strategie, um zu malen.

JB: Ich habe immer versucht, in meinen Arbeiten Malerei und Fotografie miteinander zu verbinden. Da bin ich dem wohl am nächsten gekommen.

MC: Ich mag die ganze Serie. Die Bilder sind so seltsam. Als ich sie zum ersten Mal sah, habe ich sie gar nicht als Deine Arbeiten erkannt.

JB: Sie haben die Leute total verwirrt. Antonio Homem von der Sonnabend-Galerie meinte, als er sie sah: "Du hast einfach die Bilder der letzten Ausstellung aus den neuen Arbeiten rausgenommen."

MC: "Telephone (for Kafka)" aus dem Jahre 1991 zeigt ein nierenförmiges Foto von Glamourtypen an einem Pool und die Schwarzweißaufnahme eines total entsetzten Mannes am Telefon. Was verbindet die Motive?

JB: It totally baffled people. Antonio Homem at Sonnabend Gallery said, when I showed that body of work, "You left out the show before this."

MC: "Telephone (for Kafka)", 1991, shows a large sort of kidney shaped photograph of glitzy people by a pool and a black and white image of horror struck man talking on the telephone. What is the relationship between the two elements?

JB: Put very simply, it's about communication and something about not knowing who you're talking to. The shape was sliced out of a movie still. It was the only thing that interested me in the photograph. It's so gross – the drink on the pool, the babe with the boobs, the guy on the phone, everyone with suntans. This other photograph was from a film that was actually a comedy but this guy seems so totally revulsed.
I thought of Kafka and that's why it's called "Telephone (for Kafka)". I am making story out of it. It's as though the figure here is saying, "Oh my God this guy is phoning me." Imagine Kafka having these guys (*the people with suntans*) as neighbors? Neighbors from hell.

MC: Is the irregularly shaped element meant to echo the shape of the cell phone or the pool?

JB: No, I hadn't thought of that. I had this attitude of war against squares, rectangles and right angles. I just drew a line around the stuff that interested me. That created the shape. The rest wasn't of interest to me so I just left it out.
I tend to align myself with this (*the Kafka character*) and this is the stuff that frightens me and yet I know I am part of.

MC: But, if you hung "Telephone (for Kafka)" in a Las Vegas casino people might see it the opposite way. They might say, I can understand the people by the pool but who's this jerk?

JB: Ganz einfach gesagt, geht es um Kommunikation und darum, daß man manchmal nicht weiß, mit wem man eigentlich spricht. Die Form habe ich aus einem Filmstill ausgeschnitten. Sie war das Einzige, was mich an der Aufnahme interessiert hat. Sie ist so vulgär – die Trinkerei am Pool, das Mädchen mit den Brüsten, der Typ am Telefon, alle sonnengebräunt. Die andere Aufnahme stammt aus einem Film, der eigentlich eine Komödie ist, aber der Mann schien völlig aus der Fassung geraten.
Dabei ist mir Kafka eingefallen, und deshalb heißt die Arbeit "Telephone (for Kafka)". Ich verbinde die Bilder zu einer Geschichte. Es ist, als würde der Mann am Telefon sagen: "Oh Gott, der Typ ruft mich an."

MC: Ist die Nierenform der Aufnahme ein Reflex auf die Form einer Telefonzelle oder des Pools?

JB: Nein, daran habe ich nicht gedacht. Ich befand mich eher im Kriegszustand mit Quadraten, Rechtecken und rechten Winkeln. Ich habe einfach eine Linie um das gezogen, was mich an der Aufnahme interessierte. Und das ergab dann die Form. Der Rest hat mich nicht interessiert, und deswegen habe ich ihn weggelassen.
Mit dem anderen Motiv (der Kafka-Rolle) identifiziere ich mich; obwohl es mir Angst einflößt, weiß ich, daß ich ein Teil davon bin.

MC: Aber nehmen wir an, Du hängst "Telephone (for Kafka)" in ein Kasino in Las Vegas. Da würden die Leute das möglicherweise ganz anders sehen. Sie würden vielleicht sagen, mit den Leuten am Pool kann ich mich ganz wunderbar identifizieren, aber wer ist das Nervenbündel?

JB: (lacht) Das ist wahr.

MC: Die Arbeit "Three Active Persons/With Standing Person" zeigt drei Frauen, die Aerobic treiben, und einen Mann, der am Steilufer steht und über das Meer schaut. Das untere Bild

JB: (laughs) True.

MC: "Three Active Persons/With Standing Person" (three women doing aerobics and a man standing on a bluff looking at the ocean). The lower image looks like a Casper David Friedrich painting. I couldn't decide which was sillier. The three women doing aerobics or the isolated man on the cliff. The solemnity of the landscape portion is so corny.

JB: It could be a New Age album cover.

MC: Both options seem absurd. I'm not sure what your position is.

JB: Where do my sympathies lie? With neither one. They're both cliches. But then again cliches are true too.

MC: You're influenced a great deal by writers. You've mentioned William Carlos Williams, Laurence Sterne, Kafka, Pessoa, are there others?

JB: The one that comes immediately to mind is Adam Gopnick. Did you read his story about the psychiatrist? He's writing about his last meeting with a very famous New York psychiatrist. The two of them are getting ready to make the separation and the psychiatrist is trying to give some last words – some elemental truths, and says, "Mr. Gopnick, life has very many worthwhile aspects". And Gopnick thinks, "What the fuck is this guy talking about?" He leaves the office and he is riding home in the cab thinking about it and realizes the psychiatrist is right. That's about as far as you can go. Life does have many worthwhile aspects and that's about it. It's a masterpiece.

erinnert an ein Gemälde von Caspar David Friedrich. Es fällt mir schwer zu sagen, was ich alberner finde: die drei Aerobic treibenden Frauen oder den einsamen Mann auf der Klippe. Die Landschaft ist so sentimental erhaben.

JB: Sie könnte das Cover für ein New Age Album abgeben.

MC: Beide Positionen erscheinen absurd. Ich weiß nicht, wo Du dabei stehst?

JB: Du meinst, welche meine Sympathien hat? Keine von beiden. Beide sind Klischees. Aber Klischees haben auch ihren Anteil an der Wahrheit.

MC: Schriftsteller haben Dich beeinflußt. Du hast William Carlos Williams erwähnt, Laurence Sterne, Kafka, Pessoa. Gibt es noch andere?

JB: Wer mir bei der Frage sofort einfällt, ist Adam Gopnick. Hast Du seine Geschichte über den Psychiater gelesen? Er schreibt über seine letzte Sitzung bei einem berühmten New Yorker Psychiater. Die beiden schicken sich an, sich endgültig voneinander zu verabschieden, und der Psychiater sucht nach ein paar letzten Worten – so etwas wie eine fundamentale Wahrheit, und er sagt: "Mr. Gopnick, das Leben hat viele wertvolle Seiten." Und Gopnick denkt: "Was zum Teufel erzählt der Mensch da?" Er verläßt die Praxis und fährt in einem Taxi nach Hause. Dabei denkt er über den Satz nach und erkennt, daß der Psychiater recht hat. Ungefähr so weit kann man kommen. Das Leben hat viele wertvolle Seiten – und damit gut. Das ist meisterhaft.

Die Kritik der Kunst, das Machen von Bildern und ihr Doppelgänger: John Baldessari

Art criticism, the production of images, and doubles: John Baldessari

Während der Arbeit an diesem Text befand ich mich an einem sehr entlegenen Punkt der portugiesischen Küste, einem westlichen Extrem, einem Ende Europas. Das kleine Dorf am Meer war nicht nur klein und schwer erreichbar und im Westen vom Ozean begrenzt. Gen Süden versperrte ein reißender Fluß, der den Ozean mit einem Binnensee verband, einem den Weg, gen Norden eine Steilküste mit einem zerbröckelnden Kliff. Dafür war man auch im Hochsommer ziemlich alleine. Der Tagesablauf wurde von der Natur, Ebbe und Flut, und einfachen Bedürfnissen bestimmt. Es gab keine Zeitungen, außer portugiesischen, die fast ausschließlich von lokalen Ereignissen berichteten, also nicht abzulenken vermochten, und keinen Fernseher. Doch in den Abendstunden tauchte am Strand an einem nicht genau vorhersehbaren Zeitpunkt jeden Tag John Baldessari mit einer Begleiterin auf. Unverkennbar. Ich hatte ihn zwar nur einmal im Leben und aus gewisser Entfernung gesehen, aber das war er. Leicht zu erkennen, das klassische Gesicht hinter dem langen weißen Bart. Ich wußte nicht, ob ich ihn ansprechen sollte – ob das womöglich die Arbeit an diesem Text erleichtert oder vielleicht doch nur erschwert hätte. Bevor ich darüber entschieden hatte, war er aber immer schon mit der sinkenden Sonne im Rücken mit seiner dunkelhaarigen Begleiterin Richtung Binnensee verschwunden, vorbei an dem seltsamen grauen, gotischen Anwesen, das dem Vernehmen nach einer sehr alten Vicomtesse gehörte.

Noch immer kann man, zumindest grob, zwei Diskussionen unterscheiden, die diejenigen Milieus der Bildenden Kunst beherrschen, die sich noch einer kritischen Kultur verpflichtet fühlen. Beide scheinen nicht nur inhaltlich, sondern auch in Bezug auf ihre Milieus und Institutionen, zunehmend unver-

During my work on this essay, I happened to find myself in a very isolated spot on the Portuguese coast, at one of the westernmost tips of Europe. Bounded by the Atlantic Ocean on the western side, the small village was also very difficult to reach from the inland, for one's way was blocked on the southern side by a raging torrent which gushed into the ocean from a nearby lake, and, to the north, by a steep, crumbling cliff. By way of consolation, one could enjoy the peace and quiet here, for one was very much alone, even during the summer months. Daily routine was largely dictated by natural phenomena, high and low tide, the simple needs of life. There were no newspapers, except Portuguese ones, which reported almost exclusively on local events and happenings and were not, therefore, a distraction, and there was no television. But every evening, around the same yet never exactly foreseeable time, John Baldessari and a female companion would suddenly appear on the beach. It was definitely Baldessari. Although I had seen him only once before, and from some distance, it was him alright. There was no mistaking the classical features and the long white beard. I wasn't sure whether to approach him or not – whether speaking with him would make my work on this essay any the easier, or whether it might perhaps make it even more difficult. But before I could decide, he and his dark-haired companion would already be disappearing, their backs glinting in the light of the setting sun, towards the aforementioned lake, past the strange, gray Gothic residence which, by all accounts, belonged to a very old vicomtesse.

It is still possible to distinguish, at least roughly, between the two debates which dominate those camps of the visual arts that still feel committed to a culture of criticism. Both seem to

bunden. Das eine wäre die Gesamtheit der Fortsetzungen derjenigen Diskussionen, die am Kunstbegriff oder am Kunstanspruch ansetzen – oder zumindest die Disziplin, in der über Bildende Kunst gesprochen wird, die Kunstgeschichte, noch immer an dem doppelten Anspruch umfassender Kritik und den "hohen" Qualitäts-Standards einer Hochkultur festmachen wollen. Hier geht es nach wie vor um die Frage, wer oder was eine Aktivität als Kunst legitimiert, ob diese Legitimation wünschenswert ist und wen oder was sie ein- oder ausschließt. Im Zentrum dieses Diskurses stehen in der Regel die Institutionen, die der Archivierung und Repräsentation – also Museen, Galerien, das Prinzip des "White Cube" etc. – ebenso wie die der Erziehung und Ausbildung, das Verhältnis Kunst und Öffentlichkeit, sowie, allgemeiner und grundsätzlicher, das von Kunst und Politik. Ein Beispiel für diese Debatten wäre in den Diskussionen der Dia Art Foundation während der späten 80er und frühen 90er zu finden, in den Round Tables von "October", in Deutschland etwa beim "Methodenstreit", den die Zeitschrift "Texte zur Kunst" Ende 1997 in Berlin veranstaltete und der erneut die Frage nach kritischer und linker Kunstkritik stellte. Dabei geht es immer auch darum, ob gerade das Festhalten am Begriff der Kunst einen Gewinn für kritische Positionen bieten kann. Zwar stellte Benjamin Buchloh schon 1987 – beim ersten Dia Art Foundation Panel – fest, daß der kritische Ansatz in der Kunstkritik jeden Boden unter den Füßen verloren hätte, möglicherweise aber in der Kritik der Massenkultur noch einen Sinn hatte und warf sich selbst und seinen Co-Panelisten Rosalind Krauss und Michael Fried das Ignorieren der Massenkultur[1] vor, hielt selber aber auch 1997 – beim "Methodenstreit" in Berlin – noch strikt daran fest, daß massen- oder subkulturelle Phänomene unmöglich Gegenstände von Kunstkritik werden könnten und z.B. Elvis Presley im gleichen Maße wie Jackson Pollock eine periodisierende Funktion zugebilligt werden könnte. Ähnlich massiv verteidigte Rosalind Krauss einen exklusiven Kunstbegriff, um das Boot der Disziplin Kunstgeschichte wasserdicht gegen eine See von Anfeindungen und Versuchungen zu machen, die vor allem die steigende Flut der Cultural Studies meinte.

have become increasingly divorced from each other, not only in terms of content but also as regards their respective environments and institutions. On the one side there is the debate which embraces all those ongoing discussions whose starting points are invariably such questions as "what is art?" or "what may claim to be art?" – or if not these, then at least the very discipline which governs the discussion of art, namely art history – and whose principles are still very much bound up with the duality of comprehensive criticism on the one hand and the "high" quality standards of an advanced civilization on the other. At the center of these discussions are, as a rule, those "white cube" institutions – i.e. museums and galleries – that have an archiving and representational function, and also the institutions concerned with education and training, whereby "art and public" and, in a more general and fundamental context, "art and politics" are prevailing themes. Typical examples of these discussions are the ones conducted by the Dia Art Foundation during the late eighties and early nineties, the Round Tables of "October", and the "Methodenstreit" in Germany, which was organized by the magazine "Texte zur Kunst" towards the end of 1997 and dealt anew with critical and left-wing art criticism. Here the question is always whether adherence to a specific concept of art can be of any benefit to criticism. Whilst Benjamin Buchloh – as one of the members of the first Dia Art Foundation Panel in 1987 – suggested that the critical approach no longer stands on firm ground in art criticism but might possibly still make sense in the criticism of mass culture, at the same time reproaching both himself and his fellow panellists, Rosalind Krauss and Michael Fried, for their ignorance of mass culture[1], he still maintained, ten years later – at the "Methodenstreit" in Berlin in 1997 – , that mass or subcultural phenomena could not possibly become the subject matter of art criticism and that, for example, a periodizing function could be ascribed just as much to Elvis Presley as to Jackson Pollock. It was with similar vehemence that Rosalind Krauss defended a specific concept of art in order to render the ship of "Art History" watertight against a sea of hostilities

In das Feld der Diskussionen, bei denen ein Kunstbegriff noch eine entscheidende Rolle spielt, wären auch gewisse Stränge der – vorwiegend in Deutschland geführten – Mahnmaldebatte einzutragen, in der – anläßlich der Beteiligung von Richard Serra an Eisenmans ersten Entwurf – wiederholt die Frage diskutiert wurde, ob die Kunst als irgendwie autonome Instanz gerade nicht oder gerade ganz besonders geeignet sei, auf das "Unaussprechliche" des Holocaust Bezug zu nehmen, ja gar es auszusprechen. Auch die letzte Documenta bezog sich in mancherlei Hinsicht auf diese Diskussionen und stellte nicht nur zentrale Arbeiten aus diesem Zusammenhang in den Mittelpunkt ihrer Bestandaufnahme, das "Atlas"-Projekt von Gerhard Richter und das "Musée des Aigles" von Marcel Broodthaers, sondern bemühte sich auch darum, den Prozeß der Diskussion durch die Reihe "100 Tage/100 Gäste" auszustellen.

Die andere und gegenläufige Debatte kommt weitgehend ohne den Kunstbegriff aus. Sie versammelt sich viel eher um den der Visualität, der Bilder und Bilderwelten und ist an Fragen der Repräsentation nicht so sehr im Zusammenhang mit den Institutionen interessiert als im Zusammenhang der Alltags- und Massenkultur oder dem von Pop-, Sub- und Gegenkulturen. Eine wesentliche Frage gilt dem Einfluß neuer Technologien der Bildproduktion und -reproduktion und die vielfältigen, damit zusammenhängenden Verschiebungen und Umschichtungen der Bildkonsumption im sozialen Gefüge. Diese Debatten werden stark mit dem Begriffsbesteck, das sowohl die britischen Cultural Studies als auch und vor allem ihre US-amerikanischen Entsprechungen entwickelt haben, gefuhrt. Interdisziplinarität wird dabei groß geschrieben: Philosophie, Soziologie, Kunst- und Kulturwissenschaften fließen mit ein und dazu kommen auf bestimmte politische und soziale Fragen zugeschnittene, meist aus der Literaturwissenschaft entstandene Neben- und Tochterdisziplinen wie Queer Studies, Women's Studies oder Postcolonial Studies, die unter anderem auch auf die Erwartungen eines spezifischen Nutzens dieser Diskussionen für konkrete politische Auseinandersetzungen verweisen.

and experiments, by which she meant the tidal wave of "Cultural Studies".

A not insignificant contribution to those discussions in which a specific concept of art plays a decisive role has been made by certain developments in the Holocaust Memorial debate, which has been taking place mainly in Germany. Richard Serra's participation in Eisenman's first design for this memorial has prompted, time and time again, the question as to whether art, as a somehow autonomous authority, is a particularly suitable – or a particularly unsuitable – medium through which the "unutterability" of the Holocaust can be conveyed, indeed uttered. The last documenta, too, referred in many a respect to these discussions and not only drew attention to works that are significant in this context – Gerhard Richter's "Atlas" project and Marcel Broodthaers "Musée des Aigles«, for example – but also sought to visualize the discussion process through its accompanying series of lectures and discussions "100 Tage / 100 Gäste".

The other debate takes us in a completely different direction and largely waives the need for a specific concept of art. It is oriented more towards a concept of visuality, of images and of worlds of images, and its interest in questions of representation has less to do with the institutions than with everyday and mass culture, with pop, sub and alternative cultures. One of the questions central to this debate concerns the influence of new image production and reproduction technologies and the shifts and changes in image consumption that are constantly taking place in our society as a result. Participants in the debate are for the most part armed with the terminology both of British "Cultural Studies" and, more so, of their US counterparts, the interdisciplinary aspect being high on the list of priorities: philosophy, sociology, the arts and humanities, all have their part to play, together with other, subsidiary disciplines, originating mainly in literary studies and tailored to specific political and social phenomena, such as Queer Studies, Women's Studies and -

Ich will den ersten, den neo-institutionskritischen Debatten-kreis als post- und neokonzeptuell bezeichnen, den anderen mit dem in letzter Zeit modisch gewordenen Term Visual Culture. Obwohl es einige personelle und inhaltliche Über-schneidungen gibt, scheint mir doch zentral für die dennoch relativ ausgeprägte (und überraschende) Getrenntheit der bei-den Debatten die Tatsache, daß die eine weitgehend ohne Kunstbegriff auskommen kann, während die andere sich für Bildkonzepte nicht sehr interessiert. Man wird schon ahnen, daß an dieser Stelle John Baldessari, der offensichtlich am Kunstbegriff wie am Bildbegriff ein immenses kritisches und praktisches Interesse hat und vor allem an einer bestimmten unauflöslichen Verbundenheit der beiden, nun endlich seinen Auftritt haben müßte, aber schieben wir diesen noch ein bißchen hinaus. Schicken wir erst noch ein paar diskursive Supporting Acts auf die Bühne.

Die Getrenntheit der Debatten hat nicht nur ihre Ursachen in den Interessengebieten der Debattierenden und deren etwaige harte institutionelle und disziplinarische Grenzen, sondern auch in den Arbeitsteilungen, die das Gebiet der Bildenden Kunst selbst betreffen, sowohl intern als auch im Verhältnis zu benachbarten Gebieten. In der post- und neo-konzeptuellen Kunst und den sie begleitenden Kritiker- und Intellektuellenkreisen scheint es eine ausgemachte Tatsache zu sein, daß die Bildherstellung selbst kein Arbeitsgebiet eines zeitgenössischen bildenden Künstlers mehr sein kann. Seit vielen Jahren ist klar, daß der zeitgenössische Bildkünstler mit Bildherstellungsweisen als verdinglichte und vergesellschaf-tete Praktiken außerhalb seines Einflußbereichs nur umgeht: sie anordnet, ausstellt, problematisiert etc., aber nicht selber hervorbringt. Bildproduktionsweisen sind nicht nur auf der technischen Ebene industriell determiniert. Die Aufgabe der Künstler kann es allenfalls sein, unter Zuhilfenahme dieses Materials Aussagen über sein Zustandekommen und auch darüber hinausgehende, "geistige" (Duchamp) Ideen zu ver-mitteln, die nicht von den retinalen Informationen, die der Bildhersteller oder der Bildherstellungsprozeß zu verantworten

Postcolonial Studies, studies which, moreover, also seek to derive a specific benefit from these discussions for actual political discourse.

I would define the institutionally oriented debate as "Post- and Neo-Conceptual", whilst the most suitable term to describe the other would be "Visual Culture", a term which has become very fashionable of late. Although in some areas they overlap, both in respect of their participants and with regard to content, there is one fact which seems to me to be central to the relatively marked (and surprising) difference between the two debates, namely that the one debate can more or less waive the need for a specific concept of art whilst the other is not all that in-terested in visual concepts. The observant reader will doubtless suspect that it is precisely at this juncture that John Baldessari, who takes an immense interest, both critical and practical, in art and visual concepts alike, indeed, in a certain inseparable fusion of both, ought to make his appearance. But let us post-pone his entrance for just a little longer and, in the meantime, put a couple of discursive supporting acts on the stage.

That two completely different debates have come into being is causally related not only to the fields of interest of their respective participants and to their institutional and disci-plinary limitations, but also to the divisions which exist within art itself, not just internally but also in its relationship with neighbouring fields. In Post- and Neo-Conceptual art and its concomitant circles of critics and intellectuals, it seems to be an accepted fact that the production of images itself can no longer be the contemporary visual artist's field of activity. For many years now it has been obvious that the visual artist does not produce images himself – their methods and means of production being, as reified and socialized practices, beyond his sphere of influence – but, rather, merely does something with them: he arranges them, exhibits them, treats them as problems, and so on. Whilst the various methods and means of image production are basically technical and/or industrial, the artist is able to convey, besides merely factual informa-

haben. Ebensowenig interessieren in der Regel die "unmittel-baren" oder "primären" Stadien des Bilder-Sehens, die physische oder psychologische – der lange und natürlich berechtigte Kampf gegen falsche Unmittelbarkeit hat nahezu jedes Interesse an dem Interface Auge und Gesichtssinn ausgelöscht.

Entsprechend ist der Gegenstand der Kunstdiskussion selten Visualität, sondern bestenfalls Metavisualität. Daß dies so ist, irritiert niemanden mehr, schließlich gehen mittlerweile ja oft schon massenkulturell kursierende Bilder-Produzenten mit dieser Tatsache um, etwa in der Werbung. Die Künstler, die trotzdem noch oder wieder auf die Hervorbringung von Bild-typen als primäre Aktivität Wert legen, finden sich – und das auch meistens nicht zu Unrecht, wenn auch meistens aus anderen Gründen – auf der ungünstigen Seite einer nicht oft ausgesprochen, aber vielfältig virulenten High/Low-Unterscheidung. Und wie immer schon bei dieser Unterscheidung vermag sie möglicherweise ein kommerzieller Erfolg zu trösten.

Ein erstes Unbehagen über die Reibungslosigkeit dieser Unterscheidung zwischen hoher, antiretinaler, sekundär bildver-arbeitender und niederer retinaler, primär bilderproduzieren-der Kunst mag sich bei Phänomenen wie Neo-Expressionismus in den frühen 80ern gezeigt haben – doch waren die meisten Vertreter dieser und anderer Bewegungen – von Ausnahmen abgesehen – zu leicht als neo-konservative und restaurative Geister zu erkennen, um als kritische Herausforderungen ernst genommen zu werden. Brisanter war eher, daß eine Entwick-lung außerhalb der Bildenden Kunst, also neue visuelle For-men im Gebiet von Kino, Video, Design und vor allem digita-len Bildträgern im Laufe der 90er auch eine starke akademi-sche und theoretische Unterstützung fand, die auf der akade-mischen Ebene, als akademische Debatte z.B. unter den Namen "Visual Culture" konkurrent zu der Monopolisierung des kritischen Ansatzes durch die Diskussion der post- und neokonzeptuellen Diskurs-Kultur auftrat.

tion about their coming into being, "intellectual" ideas (à la Duchamp) which reach beyond the purely retinal information furnished by the act or means of image production. Also of little interest are the "immediate" or "primary" stages of the image-viewing process and the physical or psychological effects inherent in them – the long and, naturally, justified struggle against errant immediacy has wiped out virtually all concern for the eye and our faculty of seeing.

Consequently, the subject matter of discussions on art is rarely visuality but, at best, metavisuality. That this is so bothers nobody any more. Even the images of mass culture – in advertising, for example – testify to this. Those artists who still – or again – see the production of images as their primary purpose now find themselves – and mostly not without good reason, though the reason rarely has anything to do with the matter in hand – on the wrong side of a high/low divide which, whilst being seldom expressed, is virulent in a variety of ways. And, as is always the case with such divides, con-solation may possibly be sought in commercial success.

Although an incipient unease about the complete absence of any friction between the high, non-retinal art on the one side of the divide – where the image plays only a secondary role within the process as a whole – and the low, retinal art on the other side – where the image, and its production, are of primary importance – may indeed have been manifest in such phenomena as the Neo-Expressionism of the early eighties, most of the exponents of this and other movements – with just a few exceptions – were obviously too neo-conservative and reactionary to be considered a serious critical challenge. Much more explosive, on the other hand, was the fact that, during the nineties, a development outside the sphere of art, namely the creation of completely new visual forms in the fields of film, video, design and, above all, digital imaging, was enjoying ever increasing support from academics and theorists and, on the level of academic debate, was challenging – under the banner of "visual culture«, for example – the monopolizing tendency

Diese Konkurrenz wurde in dem Moment besonders deutlich, wo die Vertreter des Visual-Culture-Ansatzes, die also von einer relativen Gleichbehandlung visueller Phänomene – vor dem Hintergrund der Qualität, der Authentizität, des Werk-Kontexts etc. – ausgingen und Bildender Kunst nicht per se einen privilegierten Ort zuweisen, auch über Bildende Kunst schreiben. Wenn etwa Irit Rogoff sagt, "I would like to make it clear that neither the artist nor his intentions are the subject of my discussion and are not of much concern to me. Issues of artistic quality, the authenticity of authorial voice and of ideological soundness seem to be redundant categories of analysis when applied to the attempt to understand visual culture as the disintegration of the unity of visual discourses"[2], dann schafft sie ein Problem für den neo- oder post-konzeptuellen Diskurs. Denn der gibt ja auch keinen Pfifferling mehr auf die hier geschickt von Rogoff ins Spiel gebrachten, traditionellen Kategorien künstlerischer Legitimität: dennoch möchte er den Kunstbegriff nicht aufgeben und er möchte – im weiteren Sinne – auch nicht auf die Idee künstlerischer Qualität verzichten. Er müßte also erneut die spezifische (kritische) Qualität Bildender Kunst im Zeitalter der benannten Desintegration einheitlicher visueller Diskurse begründen. Vielleicht kann mein Text dazu unter Bezugnahme auf die Arbeiten von John Baldessari etwas beitragen.

Es gibt aber auch ein Problem für den Diskurs der Visual-Culture-Schule, wie ich ihn hier einmal am Beispiel von Rogoffs Text exemplifizieren will. Denn wenn künstlerische Intentionen und Qualität unwichtig geworden sind und der Interpretin visueller Phänomene diese nur als mehr oder weniger anonyme Symptome gesellschaftlicher und historischer Entwicklungen erscheinen, die nur gelesen werden müssen, passiert etwas Ähnliches, wie in der Privilegierung nichtbildproduktiver, sekundär visueller oder metavisueller künstlerischer Aktivität in der post- und neokonzeptuellen Denk-Richtung. Der "Sinn" der visuellen Phänomene wird erst auf einer zweiten Ebene konstituiert – entweder auf der künstlerischer Re-Arrangements (Post/Neo-Konzept) oder auf der einer ideologiekriti-

of the critical approach to the discussion on art as pursued by the Post- and Neo-Conceptualists.

This challenge would become particularly clear whenever the exponents of the Visual Culture approach, that is to say, the approach that starts out from a relatively egalitarian treatment of visual phenomena – against the background of the quality, authenticity, context of the work etc. – and does not consider art per se to be worthy of a privileged position, actually wrote about art. When Irit Rogoff writes, "I would like to make it clear that neither the artist nor his intentions are the subject of my discussion and are not of much concern to me. Issues of artistic quality, the authenticity of authorial voice and of ideological soundness seem to be redundant categories of analysis when applied to the attempt to understand visual culture as the disintegration of the unity of visual discourses,"[2] she is certainly creating a problem for the Neo- and Post-Conceptual discourse, for whilst the latter no longer cares one jot or tittle about those traditional categories of artistic legitimacy which Rogoff here skillfully brings into play, it would not wish to waive its concept of art or renounce the notion of artistic quality in its broader sense. Thus it will have to reappraise the specific (critical) quality of art in our age of "the disintegration of the unity of visual discourses," as Rogoff puts it. Perhaps my essay can, with reference to the work of John Baldessari, make some contribution to this end.

There is, however, a problem for the visual culture discourse, too, and this can likewise be exemplified with the aid of Rogoff's text: if artistic intentions and quality have become unimportant and the writer, as an interpreter of visual phenomena, sees them merely as more or less anonymous symptoms of social and historical developments which only need to be read, then what takes place here is similar to what takes place in the Post- and Neo-Conceptual discourse which favors art of the non-imaging, secondarily visual or metavisual kind. The "meaning" of the visual phenomena is interpreted on another level – either on that of artistic re-arrangement

schen, phänomenologischen oder hermeneutischen Lektüre durch die kritischen Auswerter anonymer VC-Phänomene (Visual-Culture-Diskurs).

Mein Einwand ist nicht so sehr, daß das nicht der Fall ist: daß also nicht tatsächlich ein großer Teil des diskutierbaren Sinns visueller Phänomene auf der Ebene der sekundären kritischen Arrangements oder ideologiekritischen Lektüre entsteht, nur antworten beide Verfahren nicht auf die notwendig gewordene Neubestimmung und Bewertung bildproduzierender Praktiken unter den Bedingungen neuer elektronischer Medien wie auch bildlesender und -sortierender Primärpraktiken auf Seiten des nichtakademischen Publikums solcher Bilder. So wie der spätkonzeptuelle Ansatz die Techniken der Distanzierung, des Framing, der Metasprache vor jede Bildauswertung stellt (und von der von ihm bevorzugten künstlerischen Praxis dazu gezwungen wird), so übertreibt der VC-Ansatz die Lektüre von Bildern als lesbare Bestandteile einer medienübergreifenden und bildtypübergreifenden großen kulturellen Konversation, die auf einem allgemeinen Zeichenaustausch basiert. Bilder bringen dann zwar andere Zeichen hervor, aber letzten Endes auch nur Zeichen – und da ist es völlig egal, ob der fragliche Gegenstand gemalt, gesprayt, gefilmt, fotografiert oder gepixelt ist und vor welchem Hintergrund: er ist lesbar.

Bevor also Rogoff im fraglichen Fall, wo sie den Zusammenhang zwischen dem deutschen Historikerstreit und der Mahnmalsdebatte mit Gemälden von Jörg Immendorff sowie Arbeiten von Beuys und Jochen Gerz diskutiert, den Sinn der besagten visuellen Phänomen in bezug auf eine politische Konstellation sammelt und bewertet, sind all diese Phänomene schon einmal gelesen und bewertet worden – ohne daß wir etwas davon wissen, wie und mit welchem Ergebnis diese Prozesse verlaufen sind. Wir können am Ende darauf zurückgreifen und uns darauf verlassen, daß sie Zeichen geworden sind. In diesem besonderen Fall handelt es sich dabei sogar um Prozesse, die in der relativ gut dokumentierten und rekonstruierbaren Welt von Galerie- und Museums-Ausstellungen

(Post-/Neo-Conceptual concept) or on that of an ideology-critical, phenomenological or hermeneutic interpretation by the analysts of anonymous VC phenomena (Visual Culture discourse).

My objection is not so much that this is not the case, that much of the discussible meaning of visual phenomena is not in fact interpreted on either of the aforementioned levels, but, rather, that neither the Post- and Neo-Conceptual camp nor the Visual Culture camp has responded to the meanwhile pressing need to redefine and evaluate both the image-producing methods now possible with new electronic media and the primary image-reading and image-sorting habits of a non-academic audience. Like the late conceptual approach, which puts the techniques of detachment, framing, metalanguage before any analysis and/or evaluation of the image (indeed, it is forced to do so by the very nature of the artistic method it prefers to use), the VC approach exaggeratedly interprets images as legible components of a comprehensive, all-embracing (all-embracing in the sense that it embraces all kinds of media and all types of image) cultural dialog based on generally interchangeable symbols. Images may indeed operate with different symbols, but these symbols are, after all said and done, only symbols – and it is completely irrelevant whether the object in question has been painted, sprayed, filmed, photographed or digitized, and against what background – their legibility is what counts.

So before Rogoff even proceeds in her essay – in which she discusses the connection between the Historikerstreit and the Holocaust memorial debate with paintings by Jörg Immendorff and works by Joseph Beuys and Jochen Gerz – to address the meaning of these visual phenomena in the political context, all these phenomena have in fact been interpreted and evaluated at some time or other in the past – and without our knowing anything about the course, and with what outcome, these processes of interpretation and evaluation actually took. We can, in the end, fall back on them, fully relying on the fact

verlaufen sind. Man kann also wissen, daß im Kontext von Immendorffs fraglichen Gemälden – immer noch völlig unabhängig davon, was man von ihrer Qualität hält –, ein bestimmtes Symbol (Totempfahl) anders codiert ist als das universelle sprachähnliche Zeichen "Totempfahl": es sieht nämlich genauso aus wie die Stuhl- und Tischbeine von Möbelskulpturen, die er zur selben Zeit und womöglich auch in den selben oder benachbarten Räumen gezeigt hat und die bestimmte Titel hatten, die diesen Totempfählen eine ganz bestimmte Bedeutung zuwiesen, die Rogoff verfehlen muß, weil sie sich für diese Dimension von künstlerischer Intention nicht interessiert. Ihr ansonsten sehr sympathischer und von mir mit großer Zustimmung gelesener Text, der in Immendorffs Bildern einen "Counterdiscourse" zu den während des deutschen Historikerstreits vertretenen Positionen liest, gerät von ihrer Lektüre der "Bildzeichen" zu einer vermeintlichen "dyadischen Struktur" und von da zu einem Aufsatz von Dietmar Kamper – die allesamt einen Irrweg im Rahmen ihrer sonst bestechenden Argumentation markieren.

Daraus will ich nicht ableiten, daß die VC-Untersuchung sich alten Kategorien von Werk und Autor beugen sollte, sondern habe nur am gut dokumentierten Beispiel von Arbeiten aus dem Hochkulturkontext gezeigt, daß verfügbare Informationen vernachlässigt wurden und daß die Gründe für die Vernachlässigung darin liegen, daß dem primären Bildherstellungsprozeß und seiner Geschichte auch hier, in dieser symptomatologischen Lektüre, keine Aufmerksamkeit entgegengebracht wurde. Mit diesem "primären Prozeß" meine ich nicht, wie man Ölfarbe mischt oder eine Leinwand aufspannt, sondern wie wiedererkennbare oder nicht referentielle Gegenstände in ein Bild geraten und dort Aussagen komplettieren. Entsprechende Informationen liegen meist in einem noch viel größeren Maße brach, wenn es um die Lektüre und Diskussion von Pop- und Massenkultur geht, weil ja auch für diese gilt, daß uns Intentionen und Produktion wie auch primäre Rezeption einen feuchten Kehricht interessieren, wenn wir an der Desintegration einheitlicher visueller Diskurse interessiert sind,

that they have become symbols. And in this particular case we are talking about processes that have taken place in the relatively well documented and hence readily reconstructible world of gallery and museum exhibitions. Thus we know, for example, that in the context of the debate on Immendorff's paintings – quite irrespective of what we think of their quality – Immendorff's totem poles, as symbols, operate with a completely different code than the generally understood code inherent in the word "totem pole", for they look just like the table or chair legs of the furniture sculptures which he exhibited at the same time, and probably in the same or adjoining rooms, and which had certain titles that gave these totem poles quite a special meaning, but this meaning will have escaped Rogoff, for she is not at all interested in this dimension of artistic intention. In her otherwise very congenial text – I read it with extreme approval – Rogoff sees in Immendorff's paintings a "counterdiscourse" to the various views voiced during the Historikerstreit and proceeds from her interpretation of the "pictorial symbols" to the assumption of a "dyadic structure" and from there to an essay by Dietmar Kamper – all being somewhat erroneous and quite out of keeping with her otherwise convincing argumentation.

I am not implying here that the VC approach should give way to old work and author categories, but I have merely wished to show, with the aid of a well documented example of works that have attained a high status in a highly cultured society, that available information has been neglected and that the reasons for this neglect lie in the fact that not even here, in this symptomatological interpretation, has any attention been given to the primary image production process and its history. By "primary process" I do not mean the mixing of oil paint or the stretching of canvas but, rather, the way recognizable or non-referential objects can find their way into a picture and complement or complete its message. Such available information often lies fallow to an even greater extent where the understanding and discussion of pop and mass culture are concerned, for here, too, we cannot care less about intention,

die sich auflösen in so etwas wie pure gesellschaftliche Symptomatik.

Damit will ich aber nicht nur ein Plädoyer für eine materialistischere – im mehrfachen Sinne des Wortes – Untersuchung visueller Phänomene generell halten – und ich glaube tatsächlich, daß auch viele Untersuchungen, die unter dem Oberbegriff der Visual Culture, dort einiges geleistet haben. Ich möchte drei Thesen oder Thesenzusammenhänge zu diesen Debatten und ihren Aporien aufstellen, die ich an die Arbeit von John Baldessari anlehnen möchte.

1) Der konzeptuelle und neokonzeptuelle Diskurs laboriert noch immer an den ungeklärten Spätfolgen der bloßen Ersetzung visueller Konzepte durch sprachliche. John Baldessaris Werk ist von Anfang an als ein Korrektiv wie als Kompensation dieses alten und vielbesprochenen Problems aufgetreten. Der Geringschätzung oder der Vernachlässigung der Eigenlogik des Visuellen setzt er allerdings alles andere als einen Visualismus gegenüber, sondern er zeigt vielmehr beständig, wie gerade die konzeptuelle Untersuchung an den sogenannten primären Stadien des Bilderproduzierens und Bildersehens ansetzen muß. Für den spezifischen Akt der Herstellung eines zeichenhaften Verhältnisses eines Bildes zu einem Gegenstand in der Wirklichkeit fand Baldessari irgendwann den überzeugend angemessenen Ausdruck "Pronounce", prononcieren – wobei die Nuancen der Aussprache, der Prononciation in dem von mir gemeinten Beispiel – der Arbeit "Six Ways to Pronounce Fiddlestick (For L. Sterne)" – von Farbunterschieden repräsentiert sind.

2) Der Ort, an dem ich eine spezifische Verfehlung in Rogoffs Text über Immendorff gefunden habe, ist nicht zufällig und läßt sich nicht allein mit dem so generell wohl auch gar nicht gemeinten, von mir vorhin zitierten methodischen Postulat von ihr abdecken. Er ist vielmehr symptomatisch, weil er in einem Diskurs passiert, der davon ausgeht, daß in sehr zeichenhaften lektürefähigen, rhetorischen Bildern – wie denen

production or primary reception if we are interested primarily in the disintegration of the unity of visual discourses into something like pure social symptomatics.

Here I am not just making a general plea for a more materialistic – in all the different senses of the word – study of visual phenomena. Indeed, I believe that many studies carried out under the VC banner have achieved much in this regard. And it is with direct reference to the work of John Baldessari that I should now like to expound three theses – or thesis complexes – concerning these debates and their aporiai.

1) The conceptual and neo-conceptual discourse is still suffering, even today, from the unresolved long-term consequences of substituting visual concepts with linguistic ones. It is in the context of this old and much-discussed problem that John Baldessari's work has, from the very outset, been performing a corrective and/or compensatory function. His way of responding to the disregard and/or neglect of the inherent logic of the visual is, however, anything but visual. Quite the reverse, in fact, for he shows just how the conceptual approach can address the so-called primary stages of image production and reception. And for the specific act of relating, symbolically, an image to an object in reality, Baldessari at some time or other coined the term "pronounce", whereby in the example I am thinking of – "Six Ways to Pronounce Fiddlestick (For L. Sterne)" – the nuances of pronunciation are represented by different color shades.

2) The place in Rogoff's essay about Immendorff where in my opinion she is specifically wrong is not fortuitous and cannot be defended solely with her above-quoted methodological postulate, which she did not mean in a general sense anyway. On the contrary, it is symptomatic, for it occurs within the context of a discourse which operates on the assumption that in decidedly symbolic, interpretable, rhetorical images – like those of Immendorff's – there are individual visual elements which can in fact be treated like words (the image of a totem

Immendorffs – einzelne Elemente tatsächlich wie sprachliche Zeichen behandelbar sind (als Bild von einem Totempfahl gleich Wort Totempfahl), daß es also Bilder gibt, die für Literalisten sozusagen sicherer Boden sind. Baldessaris Arbeit ist gerade in diesem Zusammenhang entscheidend, weil er nämlich auf die Differenz Bildrhetorik/Sprachrhetorik gerade bei scheinbar einheitlich rhetorischen visuellen Konstellationen ausgeht. Dies tut er aber, ohne eine essentielle Differenz zu behaupten. Er verwirrt mit Rollentauschen beider und zeigt ihre gegenseitige Abhängigkeit, aber eben auch die Unmöglichkeit einer Ineinssetzung.

3) Es gibt durchaus einen privilegierten Ort der Kunst als Kritik: das ist die in der jeweiligen Bildproduktion eingelassene irreduzible Differenz der Bildrhetorik zur sprachlichen und auf einer Ebene darunter der spezifische Unterschied zwischen Iuxtapositionen von Bildern und Textbausteinen – wie auch deren Gemeinsamkeiten. Bildende Kunst kann – anders als anderweitig eingespannte, funktionalistische Bildproduktion – ihren natürlich dubiosen, aber privilegierten gesellschaftlichen Ort dazu nutzen, von dieser Differenz als Vorbedingung unseres Weltverständnisses und unserer Ideologiebildung zu sprechen. Das kann sie auch dann noch mit einem kritischen Gewinn tun, wenn sie ansonsten ganz konform verläuft, also nicht etwa das Kunstsystem dezidiert attackiert – weil das einen anderen Anspruch von Kunst betrifft. Ein so wie jetzt von mir reformulierter kritischer Anspruch von Kunst nimmt sich in der Tat zurück: er beharrt auf der Formulierung von Kritik, aber auf eine elementare und möglicherweise akademische, nicht unmittelbar an die Bedürfnisse täglicher Ideologiekritik anschlußfähigen Weise, als Grundlagenforschung. Damit kann man sich natürlich nicht zufriedengeben: gleichzeitig muß man auch Galerien niederbrennen. Aber für heute sollte man die in Ruhe lassen, die in der anderen Galerie Bilder aufhängen, die selber die Quadratwurzeln der Bild-Text-Produktion Ideologie zu ziehen versuchen. Schließlich glaube ich, daß über die Differenz zwischen absichtlicher und unabsichtlicher Iuxtaposition von Bild und Text, aber auch von

pole corresponding to the word "totem pole", for example), in other words, there are certain images in which literalists are, as it were, on absolutely safe ground. And it is precisely in this context that Baldessari's work is of such decisive importance, for he thematizes the difference between the rhetoric of images and the rhetoric of language – and precisely in such cases where the visual situation seems uniformly rhetorical – but without asserting any essential difference. He confuses us by constantly reversing their roles, demonstrating at one and the same time their mutual dependence and the impossibility of their ever coming to terms with each other.

3) Art does indeed have a privileged place in society as a critical entity, and on two levels: firstly, on the level of the irreducible difference between the rhetoric of images and the rhetoric of language in the process of image production, and, secondly, on the level of the specific difference – and also the common features – between juxtapositions of images and texts. Art can – unlike other image-producing processes that are purely functionalist – use its naturally dubious, yet privileged social position as a platform from which it can proclaim this difference to be a pre-condition both for our understanding of the world and for our ideological development. And art can, as a critical entity, make enormous gains, even if it conforms in every other respect, that is to say, if it does not attack the art system to any decided degree – for that is another end to which art lays claim. The kind of claim to criticism reformulated in the way I am reformulating it here does indeed withdraw: whilst it still insists on criticizing, it does so in an elementary – and possibly academic – way which is not directly linked with the needs of day-to-day ideological criticism but, rather, functions as a kind of basic research. One cannot of course be satisfied with just that; one must burn down the galleries, too. But for the time being, at least, we ought to leave them in peace, the people who are hanging pictures in the other gallery and trying themselves to formulate the ideology of text-and-image production. I believe, in the final analysis, that the quickly changing differences and

Bild und Bild und Text und Text die flüchtig bestehenden Abstände und Positionen ausgehandelt werden, die heutzutage an die Stelle der monolithischeren Fronten Ideologie und Kritik getreten sind. Um sich in ihnen auszukennen, muß man die Grundlagenforschung betreiben, die John Baldessari betreibt und darum möglicherweise traditionell bürgerliche oder andere Räume schaffen, oder man muß sehr sehr nahe am Material sein. Man hat auch hier den Eindruck, Baldessari tut beides: im Sturm des Zapping sein Schiff steuern und es sich in den Blasen weißer Kuben gemütlich machen.

Nun war es aber auch möglich, sich vorzustellen, daß durch den Entzug der gewohnten Mengen aktueller Bilder, die nicht mehr ganz aktuellen, die knapp davor liegen, noch einmal in einen Zyklus der Prozession oder Verdauung eintreten. Vielleicht war die Präsenz des Baldessari-Mannes im Abendlicht einer Doppelbelichtung geschuldet. Weniger glaubte ich an ein Schuldgefühl, daß die Pflicht, den Text zu schreiben, den Mann hervorbrachte, als Vertreter der Pflicht, doch daß es zwischen diesem Mann und Baldessari ein Tertium Comparationis gab, einer, dem dieser ähnelte und der wiederum Baldessari ähnelte. Das konnte gut sein. Die portugiesischen Zeitungen feierten in diesen Tagen ausführlich den 100. Geburtstag von Ernest Hemmingway. Für's erste wollte ich mich mit dieser Hypothese zufrieden geben: es war nicht Baldessari, es war ein Hemmingway-Doppelgänger, von denen sich vor kurzem in Pamplona hunderte getroffen hatten, und die in ihrer Vielfalt an Ähnlichkeiten und Abweichungen vom Original auch für Baldessari einen Platz gehabt hätten. Ich hatte einen Film darüber im Fernsehen gesehen.

Zum ersten Punkt. Wie konnte die Beschreibung eines Bildes, Bildinhaltes, Projektes, möglichen Bildes etc. das Bild ersetzen, wenn die ersetzende Substanz "Sprache" auch vorher schon im Bild enthalten gewesen war, Bilder nicht ohne Texte, Bildunterschriften, Illustrationsfunktion, Beschriftungen etc. auftauchten und miteinander in rhetorikartigen Beziehungen verbunden waren, wo immer es sie gab. Wenn also die Literarizität

standpoints – these having nowadays taken the place of the more monolithic fronts of ideology and criticism – about whether and to what extent juxtapositions of image and text, and also image and image and text and text, are either deliberate or unintentional are a matter of negotiation. And in order to be entirely familiar with them, we must resort to the kind of basic research which John Baldessari pursues and create traditionally bourgeois or other relevant environments and/or operate in very close proximity to the material. One's impression here is that Baldessari does both: he steers his ship through the storm of "zapping" and makes himself comfortable in the "havens" of the white cubes.

Now it was also possible to imagine that, through my deprivation of the customary enormous flood of fresh, up-to-the-minute images, those images that were no longer all that fresh had once again entered the digestive tract of my memory. Perhaps the presence of what looked like Baldessari in the light of the evening sun was due to a kind of double exposure. I did not believe that it was a feeling of guilt, that is, a sense of obligation engendered by the essay I was writing, which made Baldessari appear on the scene, as duty personified, as it were, but, rather, that between this man and Baldessari there existed a tertium comparationis, a common element, someone who looked both like him and like Baldessari. As the Portuguese newspapers were currently celebrating, at great length, Ernest Hemingway's centenary, I considered this to be the most acceptable explanation: it wasn't Baldessari, it was a Hemingway double, one of the many hundreds of doubles who had recently convened in Pamplona and who, in their whole diversity of similarities with, and deviations from, the original, would certainly have found a place for Baldessari in their midst. I had seen a film about it on TV.

I should like to make my first point by posing the following question: How could the description of an image, of its content and meaning, of its potential effect etc., possibly replace the image if the substitute, namely language, was a component

der Kunst erst möglich machen konnte, die Ersetzbarkeit visueller Konzepte durch sprachliche zu demonstrieren, dann war durch das Bestehenlassen der Sprache wohl auch ein immer schon vorhandener Bestandteil des Visuellen unaufgelöst in die Transformation mithinein genommen worden. Die Transformationen und Demonstrationen der ersten Generation der Concept-Art hätten demnach nur Sinn, wenn sie das Material, das es zu transformieren gilt, wie auch dasjenige, in das es zu transformieren wäre, als erstens zusammengesetzt und hybrid und zweitens als eben Material definieren würde, nicht als bloßes Material versus reine Prinzipien der Abstraktion.

In vielen bekannten Arbeiten – den "A Work by…"-Bildern, der "National-City"- oder der Schrift-auf-Leinwand-Serie – aus der Zeit zwischen 1966 und 1970 scheint mir Baldessari klar von diesem Punkt ausgegangen zu sein. Die potentielle Bildunterschrift ist immer schon im Bild, sowieso. Sie gehört zum Inhaltsentstehungsprozeß beim Rezipienten, sei es als explizites Zwischenstadium vor einer offenen Lösung, sei es als Endergebnis. Wenn die Bildunterschrift nun aber hingeschrieben wird oder das Bild ersetzt, entsteht ein gleichzeitig öffnender und schließender Prozeß: der Vielfalt von nicht klar formulierten Unterschriften des Betrachters wird eine gegenübergestellt, auf die hin sich die Bilddeutungsmöglichkeiten verengen – die aber gleichzeitig erst die Möglichkeit der Entstehung einer anderen alternativen, aber ebenso klaren Bildunterschrift durch den Rezipienten eröffnet, das bewußte Prozessieren von Sätzen in Bezug zu Bildern erst anschiebt. Und schließlich die entscheidende Frage stellt, ob das, was dem Satz oder dem Datum oder dem Ort auf dem Bild nicht entspricht, deswegen inkommensurabel ist, weil es eben visuell ist und einer Beschriftung spottet, sich entzieht – oder ob eine andere Bildunterschrift die Mängel der vorhergehenden ausgleichen könnte.

Schrift – das kommt hinzu – ist auch immer ein Bild, eben sogar ein Gemälde im Falle Baldessaris. Mein alter Art Director sagte damals, als ich klein war und anfing, journalistische

part of the image in the first place? In such cases, for example, where images were accompanied by texts, captions, titles, inscriptions etc. and these images and texts were rhetorically interlinked. In such cases, in other words, where it has become possible for art to demonstrate the substitutability of visual concepts with linguistic ones. Such being the case, however, the existing linguistic component of the image does not undergo any transformation. It remains an undissolved, unabsorbed part of the new concept. Viewed in this light, the transformations and demonstrations of the first generation of Conceptual Art would have made sense only if its exponents had defined both the material to be transformed and the material into which it was to be transformed firstly as a hybrid, as a combination of materials, and, secondly, as precisely that – materials – and not as an altercation between the purely material and the pure principles of abstraction.

In many of his known works produced between the years of 1966 and 1970 – his "A Work by…", "National City" and text on canvas series, for example – Baldessari seems to have proceeded from this point. The potential caption is already present in the image anyway. It forms part of the process of content recognition that takes place in the viewer, whether as an explicit intermediate stage in the process or as the end result. But when the caption is written, or when the caption replaces the image, it triggers a process which simultaneously opens and closes: the diversity of captions which have formed in the viewer's mind, albeit without much clarity or definition, are now confronted by a clearer one which narrows the scope of possible interpretation – but which, at the same time, opens up the possibility of another, alternative yet equally clear caption forming in the viewer, for it initiates a conscious processing of words in relation to images and, in the end, poses the decisive question whether the image, which corresponds neither to the caption, nor to the date, nor to the place indicated on the work, is incommensurable precisely because it is visual and defies description – or whether some other

Texte zu schreiben, immer, ein Bild ohne Bildunterschrift sei kein Bild. Es wird erst ein Bild, wenn wir ihm eine Deutung vorschlagen, denn alles andere um es herum schlägt ja auch welche vor, nur vager und unklarer. Solches gilt auch für alle Bilder im Zusammenhang der Hochkunst. Titel sind nicht nur die unsichtbare Farbe, als die sie Duchamp bezeichnete (also eine weitere Farbe, eine Ergänzung), sondern der Regelfall gegen die Ausnahme, wo jemand meint, daß der Kontext oder jedweder Kontext für ein Bild die bessere Bildunterschrift macht und daß die implizite besser ist als die explizite. Das wäre aber auch eine Entscheidung.

Das eigentliche Forschungsgebiet, das Baldessari damals eröffnete, betrifft eben Folgendes: Wie hat man sich aber das, was im Bild ist, bevor es Bildunterschrift wird, vorzustellen? Wie denjenigen sprachlichen Gehalt, der, wenn die Bildunterschrift ausbleibt, zusammen mit dem Kontext die vage, virtuelle und implizite Bildunterschrift/Titel des Betrachters ausmacht[3]. Was ist das, das manifeste Sprache – Titel/Bildunterschrift/Inhaltsbeschreibungen etc. – anspricht, ansteuert, wenn es in jedem Bild immer schon enthalten ist? Und: Ist das etwas, das industrielle, alltägliche Bilder mit anderen gemeinsam haben?

Eine erste Antwort, die Baldessari darauf gibt, in seinen Arbeiten mit Textbildern und Text/Bild-Kombinationen, ist sicher die, die er viel später in seinen Goya-Arbeiten wieder aufnimmt: Die manifesten Texte stellen sich den impliziten, unausgesprochenen als unerwartet, konfrontativ und fremd gegenüber. Sie sagen eben gerade nicht, was jeder sieht und zuerst sagen würde, sondern etwas ganz anderes: entweder eine extrem sachliche Beschreibung von Rahmenbedingungen (Datum, Lokalisierung des abgebildeten Objekts) oder extrem Unerwartetes, allenfalls Ergänzendes wie "Das habe ich gesehen!" Beiden gemeinsam ist jedoch, daß sie einen impliziten Satz des Betrachters voraussetzen: Das habe ich gesehen, enthält ein bereits als vom Betrachter sprachlich vorgebildetes, vorausgesetztes "Das". Die Datierung oder Lokalisierung setzt

caption might possibly make up for the deficiencies of the preceding one.

But there's something else: text is always an image as well, even a painting, in Baldessari's case. When I was still young and just starting out in journalism, my old art director always used to say that an image without a caption is not an image. It does not become an image until we have suggested a meaning for it, for everything else around it is likewise suggesting meanings, but these are only vague and unclear. And the same goes for all images in the context of art. Titles are not only the invisible color, as Duchamp called them (i.e. a further color, an additional component), but the general rule, rather than the exception where it is thought that the context, even any context, makes a better title for an image, and that the implicit title is better than the explicit one. But that would mean deciding, too.

The field of research which Baldessari actually addressed at that time was concerned with the following questions: How ought we to picture what was in the image prior to its transformation into a caption? Should we see it as that linguistic content which, in the absence of the caption, develops within the viewer himself and, in conjunction with the context, produces vague, virtual and implicit titles/captions?[3] What is it that addresses and/or steers towards explicit language – i.e. title/caption/description of content etc. – when this is already contained in every image? And: Is it something that industrial, everyday images have in common with others?

One of the first answers that Baldessari ever gave to these questions, in his text-and-image combinations, is certainly the one which found expression again, much later, in his Goya Series: explicit texts contrast with the implicit, unexpressed content of the images – unexpectedly, confrontationally, alienatingly. What they say in no way corresponds to what we see and what, at first glance, we would say. On the contrary, they convey something completely different: either an

die Frage "wo ist das?" oder "wann war das?" voraus, die ebenfalls ein das und ein was enthalten, die jeweils auf sprachlichen Vorbildungen des Betrachters aufbauen. Beide indizieren, daß man mit einem Betrachter kommuniziert, der schon entschieden hat, welche Fragen an dieses Bild relevante Fragen sein könnten.

Interessant ist auch, daß Baldessari das Problem zunächst dadurch löst, indem er diese sprachlichen Voraussetzungen nur ex negativo beweist, indem er darauf zeigt und jeder erkennen kann, daß es sie geben muß, nicht indem er sich der zum Scheitern verurteilten Aufgabe unterzieht, diese impliziten und unausgesprochenen Sätze zu klassifizieren oder näher in Bezug auf ein generelles Verhältnis zum Bildinhalt zu beschreiben.

Was er aber macht, ist, daß er eine dialogische Struktur jeder Bildbetrachtung (eben auch außerhalb des Kunstkontextes) voraussetzt. Der Betrachter kann die Vorformulierung seines "was" nur in Angriff nehmen, wenn er das Gefühl hat, ein Bild sei irgendwie gezielt gemeint (das muß nicht heißen, daß er

extremely factual description of the circumstances under which the image was produced (date, location etc.) or something entirely unexpected, though still in answer to a wh-question, e.g. "I saw it!" In either case, Baldessari anticipates the viewer's questions. His "I saw it!" presupposes the viewer's curiosity about "what it is" and/or "who saw it", while the date and location presuppose the questions "where is it?" and "when was it?" Moreover, Baldessari indicates, in both cases, that he is communicating with a viewer who has already decided on the relevant questions to ask about the work.

Interesting, too, is the fact that Baldessari resolves the problem, at least for the time being, by proving these linguistic presuppositions simply ex negativo, that is to say, by pointing to them so that everyone can realize they must be there, and not by making it his task – a task which would be doomed to failure from the very outset – to categorize these implied and unspoken questions or to define them in greater detail with reference to anything that might generally have something to do with the content of the work.

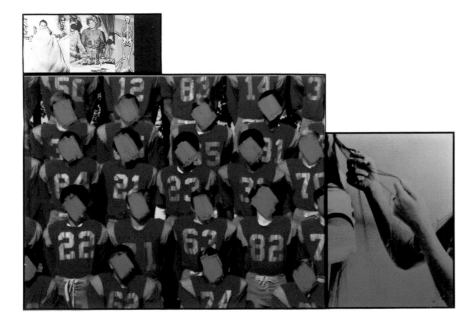

T E A M

1987

Farbfotografien, Schwarzweißfotografien, Acrylfarbe, Metallpapier/
Color and black and white photographs, acrylic, metallic paper

156 x 225 cm/61,5 x 88,5 inches

Collection of Mr. and Mrs. William Wilson III, New York

sich einen konkreten oder individuellen Autor vorstellen muß, das Erkennen einer politischen oder religiösen Richtung oder eines Witzes als witzig gemeint reicht natürlich schon). Dieses Gemeintsein ist der Hintergrund der Vorformulierung. Ein Gemeintsein kann man auch für jede zweidimensionale Anhäufung visueller Daten annehmen, wenn die denn jemand gerahmt hat und so zu einer Einheit erklärt. Das Problem zeigt aber auf das später noch wichtige Problem der Kunst, weil dort das Gemeintsein oft das Einzige ist, woran sich jemand orientieren kann und weil es sich dort um ein besonders privilegiertes Gemeintsein handelt.

Dies ist aber nur die erste Antwort, die Baldessari uns gibt. Die zweite fügt er zum Beispiel in den Arbeiten hinzu, die aus mehreren manipulierten und/oder nur dekontextualisierten Bildern bestehen, die sich über ein sprachliches Tertium Comparationis miteinander in Verbindung bringen lassen – also etwa "Team", "Box (Blind Fate and Culture)" oder "Hands/Feet" von 1987. Der Effekt, der von diesen Bildern ausgeht, ist noch

What Baldessari does do, however, is to presuppose a dialogic structure in every process of viewing, whether within or without the art context. The viewer cannot ask "what" unless he has the feeling that the image means something specific (this does not necessarily mean that he must think of an actual or a particular author, for example, but he must at least be able to recognize a religious or a political drift, or a joke as a joke etc.). This intended meaning is the background against which the viewer poses his question. An intended meaning may be assumed in the case of any two-dimensional accumulation of visual data provided someone has framed it and thus declared it to be a unified whole. This problem points, however, to the subsequent, even more important problem of art, because it is there that intended meaning is often not only our sole means of orientation but also a particularly privileged kind of intended meaning.

This, however, is only the first answer that Baldessari gives us. He follows with the second one, for example, in those works

HANDS / FEET

1988

Schwarzweißfotografien/
Black and white photographs

244/267 cm/96 x 105 inches

Private collection, Courtesy
The Lisson Gallery, London

Photograph © Susan Ormerod,
London

verblüffender und in gewissen Sinne auch unheimlicher. Unheimlich weil hier eine Tatsache unserers Weltverständnis ziemlich genau angesteuert wird, ohne sie sprachlich zu benennen, sondern nur visuell oder in einer visuell unterstützten Iuxtaposition auf sie zu zeigen; nämlich die Grenzen zwischen sprachlichen und visuellen Zeichen und ihre Austauschbarkeit und die Grenzen von Zeichen überhaupt. Dies betrifft meinen zweiten Punkt.

Viele Bilder führen – oft nach der Art eines Rebus – auf einen Satz oder ein Wort zu, das dann mit dem anderen Bildteil eine Gemeinsamkeit in Bezug auf das vom Bildtitel vorgegebene (oft nur angedeutete) Tertium Comparationis bildet. So wird die Frage "Visueller und ultimativ nichtsprachlicher Rest oder sprachlich nur noch nicht endgültig erschlossen, wohl aber erschließbar?" noch zugespitzter gestellt. Baldessari deckt bekanntlich – nicht nur bei Arbeiten, die der erwähnten Versuchsanordnung folgen – bestimmte Teile des Bildes ab,

which consist of several manipulated and/or merely decontextualized images which can be linked via a linguistic tertium comparationis – such as "Team", "Box (Blind Fate and Culture)" or "Hands/Feet" (1987). The effect which these works have on us is even more astonishing and, in a certain

die das Sprachliche betonen (der Boxhandschuh in "Box (Blind Fate and Culture)" oder einen zusätzlichen beschreibbaren, "sprachlichen" Sinn hervorbringen (die unkenntlichen Gesichter in "Team" als anonyme Masse z. B.).

Baldessari scheint also zunächst den Lesbarkeits- und Substituierbarkeits-Gläubigen (ein Bild besteht aus einer endlichen Menge Zeichen, die sich der Reihe nach oder meinetwegen auch einer komplexeren Anordnung nach dechiffrieren lassen) zuzuarbeiten. Er zeigt, wie man Bilder denotativ machen kann, und er operiert dabei mit den – oben beschriebenen – Wahrheiten aus seinen früheren Werkgruppen: Die Funktionen und Effekte der Bildunterschriften sind divers, aber, welche der oben beschriebenen es auch immer ist, der ausgestellte Text-Bild-Zusammenhang ist ein Mittel, das Bild dem Reich der Zeichen einzugliedern, unmißverständlich auf die bei der Rezeption wenn auch unausgesprochen, so doch längst signifizierten Betrachtungsroutinen zu verweisen. Nach und nach, je vielfältiger und komplexer die Text/Bild-Arrrangements – oder eben die Verweise auf sprachliche Tertia Comporationis, die nur im Titel vorkommen – werden, wird so das Bild irgendwann ganz von Zeichenhaftigkeit überschwemmt. Am Ende wäre sein imaginärer Gehalt "gerastert", restlos in Zeichen zerlegt.

Doch konnten wir ja vorhin schon sehen, daß die Bildunterschrift in ein und derselben Operation schließt und öffnet, die Tertium-Comparationis-Methode – wie ich sie mal vereinfachend nennen werde, es gibt in jenen Jahren noch einige andere, aber verwandte Versuchsanordnungen bei Baldessari – tut dies natürlich in einem noch viel größeren Maße. So wie die Finitheit des geschlossenen, hingeschriebenen Satzes, die Bildteile, mit denen er durch vielfältige Operationen in Verbindung gebracht wird, so weit wie möglich auf ihr Finites und Fixes bringt, und dadurch natürlich erst recht ihre ambivalenten, unentscheidbaren, fliehenden Anteile aufruft, tut dies die weniger finite, weniger konturierte sprachliche Figur, die die Tertia Comparationis evozieren, auch.

sense, even more uncanny, because they address, with some accuracy, a fact central to our understanding of the world, but without the use of language, that is to say, purely visually or by way of a visually assisted juxtaposition: namely our awareness of the dividing lines between linguistic and visual symbols, their interchangeability and, indeed, their limitations. And this concerns the second point I wish to make.

Many works lead – often in the fashion of a rebus – to a sentence, phrase or word which, in association with the tertium comparationis indicated (or, more often than not, simply intimated) by the title, forms a point in common with another part of the work. Thus the question "Is the remainder completely visual, non-linguistic, or can it still be interpreted in terms of language?" is posed even more pointedly. Baldessari is known to cover – and not only in works which follow the aforementioned pattern – certain parts of the image which stress the linguistic element (the boxing glove in "Box (Blind Fate and Culture)" or which give rise to an additional, definable, "linguistic" meaning (the unrecognizable faces in "team" as an anonymous mass, for example).

Thus Baldessari seems, at least at first glance, to be catering for those who adhere to the theory that, for the purpose of interpreting a work, visual elements may be substituted by linguistic ones (an image consists of a finite number of symbols which may be deciphered one after the other or, if you like, in a more complex configuration). He demonstrates how images can be rendered denotative, operating with the – above described – truths from his earlier series of works: although the functions and effects of the captions are manifold, the text-and-image combination – irrespective of the caption – remains both a means of integrating the work into the realm of symbols and of unambiguously referring to the intended mode of reception which, whilst never being expressed outright, has long since been implied. The more diverse and complex the text-and-image arrangements and/or the references to the linguistic tertia comparationis become,

Nur während im ersten Fall sich finit-fixe sprachliche Zeichen und davon nicht erreichbare visuelle Ambivalenz und Entziehungen in einer dialektischen Beziehung gegenüberstehen, sind es im zweiten Fall ein unzuverlässiger Vertreter des Sprachlichen (eine erschlossene, abgeleitete sprachliche Bedeutung) und hingegen ein visuelles Material, das auf den ersten Blick vom Künstler nicht nur mit dem sehr eindeutigen Ziel zusammengestellt, sondern auch bearbeitet wurde, auf entsprechende Weise auf Sprachliches zu verweisen. Nun ist also das Visuelle fast denotativ, das Sprachliche hingegen offen und von Konnotationen überschwemmt.

Baldessari arbeitet hier also weiter entlang der eingeschlagenen Linie, daß die beiden "Codes" nur in Zusammenarbeit Bedeutung hergeben, entfernt sich aber diesmal von der traditionellen essentialistischen Opposition, die der Sprache die Burg Denotation zu errichten zutraut, den Bildern aber endlose Weiten der Konnotation. Um Bestimmtheit zu veranschaulichen, braucht man zwar meistens Sprache als Hilfsmittel, aber Baldessari schafft es sogar fast, das zu vermeiden. Statt dessen läßt er ständig den einen Code den Job des anderen übernehmen.

Wichtig ist, daß diese Arbeiten in hohem Maße "unterstützte" Readymades sind und die Unterstützungen drastisch das visuelle Material zu verletzen scheinen, um die gewünschte Bedeutung zu unterstreichen. Das Herauskitzeln der für die Analyse entscheidenden visuellen-aber-eindeutigen Bedeutungen ist offensichtlich nur um den Preis der Gewalt bis Zerstörung der Bilder als Bild möglich, in ihnen kann der Blick nicht mehr schweifen. Das "Das", das ich gesehen habe, ist vom Künstler präpariert. Gleichwohl spielt Baldessari damit aber auch auf die Produktion von Seh-Ergebnissen und Blick-Ergebnissen an. Das, was er vorführt und zeigt, ist genau das, was das bedeutungsorientierte Sehen und Bilder-Erbeuten die ganze Zeit macht. Es produziert − oft ohne Zuhilfenahme geformter Sätze − Bedeutungen.

the latter occurring only in the titles, the more the image will become swamped with symbolism, its imaginary content eventually disintegrating into a mass of signs and symbols − like the dots of a halftone image.

But, as we have already seen, the caption opens and closes in one and the same operation. Naturally, the tertium comparationis method − which is what I shall call it for the sake of simplicity, for Baldessari experimented with other, similar methods around that time, too − does this to an even greater extent. Just as the finiteness of the self-contained, written sentence renders the image components, with which it is linked via a diversity of operations, likewise finite and fixed as far as possible, naturally evoking precisely their ambiguous, undecidable, volatile components at the same time, the less finite, less defined linguistic figure evoked by the tertia comparationis does this too.

However, whilst in the first case there is a dialectic relationship between the fixed and finite linguistic symbols and the visual ambiguity and aloofness which these linguistic symbols cannot ever achieve, in the second case the linguistic element is unreliable (an interpreted, derived linguistic meaning) whereas the visual material has − and this is obvious at first glance − not only been composed with a very unambiguous aim but also processed so as to make corresponding reference to the linguistic element. In other words, the visual element is virtually denotative, whilst the linguistic element remains opens to interpretation and is swamped with connotations.

Thus Baldessari has here continued the course already taken, that is to say, he operates with two "codes" which have a meaning only when they work in conjunction with each other, but this time he has departed from the traditional, essentialist approach that sees the linguistic and the visual as opposites, the former altogether denotative, the latter altogether, and infinitely, connotative. Whilst it is in most cases necessary to use language as an aid to visualizing things with absolute certainty,

Die Produktionsakte von Rezipienten mit denen der Produzenten zu parallelisieren, kann natürlich sehr schief gehen. Baldessari tut dies nicht offen, aber er macht es möglich und unter einem gewissen Humorvorbehalt, durch die drastischen Bearbeitungsmittel. Ihm (und mir in dieser Analyse) hilft aber dieser Umweg, auch die Produktion des Künstlers, den primären Zugriff auf Bilder, der dem Konzeptualismus sonst so prekär ist, ins Visier zu nehmen. Denn natürlich basieren auch künstlerische Bildverwendung und -produktion auf solchen Seh-Ergebnissen. Und da wird es dann nämlich doch wichtig, daß der Boxer, mit Boxhandschuh und abgedeckten Augen, ein spezifisches Aussehen hat: für die Versuchsanordnung ist nur wichtig, daß er eines hat, nicht welches. Für das Bild von Baldessari, das es geben muß, um überhaupt die Versuchsanordnung in Gang zu setzen, aus technischen, sozialen und ästhetischen Gründen, muß er ein bestimmtes Aussehen haben – zumindest wird sein bestimmtes Aussehen nach wenigen Minuten Betrachtung post festum zum nicht mehr austauschbaren Element.

Dieses Spezifische und seine Notwendigkeit ist aber eine weitere Grenze der Versuchsanordnung, die Baldessari geschickt in Szene setzt. Sie beantwortet auch die Frage nach dem Totempfahl: gerade die Darstellung einer generischen Sache durch ein Bild ist immer an die Spezifizität ihres Exempels gebunden, selbst wenn man das, wie Baldessari scheinbar, durch konzeptuelle Maßnahmen niedrig zu halten versucht: Es ist ein bestimmter Boxer und eine bestimmte Göttin vonnöten, um Boxer und Göttin denkbar zu machen. Die Unbeliebigkeit dieser bestimmten Bilder ist die Grenze eines symptomatologischen VC-Ansatzes. Für autor-orientierte Kunst kann das noch ein ignorierbarer Anteil sein, zu wissen welche Göttin, welcher Boxer, für Visual-Culture-Studies, eine Wissenschaft, die sich mit nicht durch Autoren integrierte Bildproduktion beschäftigt, wäre diese Frage aber entscheidend.

Die Tetrad- oder Elbow-Serie aus den späten 90er Jahren schließlich schließt den Kreis meiner Fragestellungen und

Baldessari even manages to waive this necessity almost entirely. Instead, he lets the one code do the work of the other.

An important point to make about these works is that they are "verbally assisted" ready-mades and that this "assistance", in underscoring the desired meaning, seems to have a damaging effect on the visual material. The process of eliciting their visual-but-unambiguous meanings, these being essential for the purpose of interpretation, is evidently possible only at the dire expense of the images as images, in the sense that the eye can no longer roam freely within them. Whilst the "it" that I saw has been conditioned by the artist, it nonetheless also serves Baldessari as a means of alluding to the production of visual results. What he shows and demonstrates is precisely what the meaning-oriented process of seeing and image-capture does all the time. It produces – often without the aid of formulated sentences – meanings.

The paralleling of the viewer's process of production with that of the producer does of course run the risk of distortion. Baldessari does not do it openly, but he makes it possible, and with a certain reservation of humor, too, through the drastic means he uses in the process. It is precisely this roundabout way, however, which helps him (and me, in this critical analysis) to consider his approach to artistic production, namely the primary access to images, the very process which is usually so precarious for the Conceptualists, for the artistic deployment and production of images is naturally based on such visual results. Indeed, this is where it is important for the boxer, with boxing glove and covered eyes, to have a certain appearance. As far as the actual process is concerned, his appearance is irrelevant; it is merely important for him to have one, no matter which. However, the image of the boxer which Baldessari has to produce in order to set the process in motion in the first place must, for technical, social and esthetic reasons, have a certain appearance - or at least this certain appearance becomes, post festum, and after only a few minutes' observation, an element which is no longer interchangeable.

nähert sich dem dritten Punkt. Man muß diesmal nicht sehr lange nach Prinzipien suchen, die Sprachliches und Bildhaftes verbinden oder verschieben, austauschen oder auswischen: Für je drei Gegenstände, einen Menschen, eine Pflanze und ein Tier, werden drei Darstellungsformen gewählt. Diese werden jeweils mehrfach bestimmt. Für die Menschen wird jeweils der Kopfausschnitt gewählt, und zwar stets repräsentiert von einem Kopf, der aus einem Werk der Malerei, der kanonischen Bildenden Kunst ausgesucht und zitiert wurde. Das technische Verfahren, mit dem zitiert wird, Ink-Jet auf Leinwand, ist eine Reproduktionstechnik, die etwa bei in Warenhäusern erhältlichen, allerdings durchaus teuren, anspruchsvollen Reproduktionen von "Meisterwerken" eingesetzt wird. Oder auch von Jeff Koons. Für die Tiere wird die Bezeichnung des Tieres in weißen Versalien auf einen schwarzbemalten Hintergrund von Hand aufgetragen. Für die Pflanzen werden sehr professionelle Fotografien der betreffenden Pflanze verwendet, wie sie in "National Geographic" oder Coffee-Table-Zeitschriften hätten Verwendung finden können.

Geht es hier also auf den ersten Blick in besonderer Klarheit um Repräsentation und Zeichensysteme, ihre Austauschbarkeit und Nicht-Austauschbarkeit? Hat Baldessari, nachdem seine Arbeiten in den 90ern oft Fragen und Projekte aus den 80ern in immer größere Komplexität getrieben zu haben scheinen, nun zu einer neuen Einfachheit gefunden? Man wird ahnen, daß wir damit nicht sehr weit kommen. Die Ellbogen-Serie ist auf vielen Ebenen subtil: Man beschäftige sich nur einmal mit der Frage, wie die Plazierung der Köpfe (oben-mitte-unten) mit der Blickrichtung der Porträtierten zusammenhängt. Doch geht es mir vor allem um einen bestimmten Aspekt, dem Problem der Kunst.

Baldessari hat ja den drei Gegenständen nicht nur beliebig bestimmte Formen der Repräsentation und bestimmte Zeichensysteme zugeordnet. Die denotativ-klassifikatorische rein sprachliche Benennung für Tiere "paßt" – in einem ironischen Sinne – zu dem sich verbreitenden allgemeinen Unbehagen

This specificity and its necessity are, however, a further parameter of the process which Baldessari skillfully sets in motion. It also answers the totem pole question, for precisely the depiction of a generic object by means of an image is always bound up with the specificity of its example, even if one seeks – as Baldessari apparently does – to minimize it with the aid of conceptual measures: a certain boxer and a certain goddess are necessary in order to make a boxer and a goddess imaginable. The specificity of these images is the limiting factor of a symptomatological VC approach. For an author-oriented kind of art, the question as to the identity of the boxer and the goddess may be largely ignored; for Visual Culture studies, a science which deals with non-author-oriented image production, this question would be of decisive significance.

Now, with Baldessari's "Tetrad"- or "Elbow"-Series of the late nineties, my deliberations virtually come full circle, bringing me to the third point I should like to make. This time there is no need for us to embark upon a long search for those principles that link, change, interchange or wipe out the linguistic and the visual: For each of the three objects – a human being, a plant and an animal – Baldessari has chosen a different form of representation. The human being is always represented by the detail of a head, quoted from a painting, a work of classic art. The medium used by Baldessari for this quote is computerized ink jet on canvas, a reproduction technique used, for example, for reproductions of "old masters" – or of Jeff Koons – usually sold in departmental stores, though this does not mean to say that they are not expensive or of the highest quality. For the animals, the name of the animal is written by hand in white capitals on a black-painted background. The plants are represented by highly professional photographs of the actual plants, photographs of the kind one would find in "National Geographic" or in coffee-table magazines.

It would seem, at first glance, that Baldessari is here concerned with representation and with systems that operate with signs

über ein bloß an Verwertungsinteressen orientierten unethischen Umgang mit (Nutz-)Tieren, die Fotografie "paßt" zu einem Schönheitsempfinden, das in der Pflanzenwelt vor allem solche Pflanzen schön zu finden bereit ist, die man noch nicht (gut) kennt, die exotisch sind: Die Fotografie muß sie gleichzeitig vorstellen und feiern. Schließlich kommt dem Menschen nicht nur in den klassischen Bilderverboten das Attribut der Undarstellbarkeit zu, daher muß ein privilegierterer Zugang gefunden werden, keine reine Abbildung, Darstellung, Repräsentation: sondern Kunst, die darüberhinaus diese Undarstellbarkeit noch einmal darstellt, indem sie sie als Willkür der Form, als Handschrift eines großen Meister repräsentiert.

Und obwohl die Wahl der Systeme also "paßt", werden sie natürlich trotzdem erkennbar demonstrativ gewählt und beibehalten. Das, was an ihrer Verwendung diskutiert wird, ist nicht nur – das ist, glaube ich, wichtig – Ergebnis einer abstrakten Versuchsanordnung, sondern eng bezogen auf heutige – und auch in diesen Text geführte – Diskussionen. Zum einen erscheinen natürlich Mensch/Malerei/Kunst als Teile einer Hierarchie von Darstellungsformen, bei der Tier/Beschriftung, Pflanze/Foto unter sich jeweils unklar, aber konventionell klar unter der ersten Konstellation rangieren. Und es geht bei der Serie ja überhaupt um Hierarchien: die Plätze sind austauschbar und es ist auch ein "Unentschieden", ein Nebeneinander möglich.

Ein Gedanke dabei, der auch nicht neu ist – weder in Baldessaris Werk noch in den postkonzeptuellen Debatten –, ist der, daß die Kunst sich von jeder anderen Bildproduktion unterscheidet und womöglich auch ihre Legitimation daher nimmt, daß sie für ein Bild den Träger und das Format genau festlegt. Der unverwechselbare und eigentlich künstlerische Akt wären alle Parameter dieser Festlegung. Nicht Weiners berühmte Anweisungen, nicht Ideen, nicht Konzepte wären demnach das Entscheidende, sondern die souveräne Entscheidung für Format, Träger, Material, Technik etc. sei unhintergehbar künstlerisch und nichtindustriell – und kann trotzdem jede industrielle Technik miteinschließen.

and symbols, and with their interchangeability and non-interchangeability. Indeed, the extreme clarity of representation immediately makes us wonder whether Baldessari, whose works in the nineties often seem to have driven the readdressed questions and projects from the eighties towards ever increasing complexity, has now discovered a new simplicity. But even as we ask the question, we realize that it will get us nowhere. The "Elbow Series" is subtle on many different levels: one merely has to ask oneself how, for example, the positioning of the heads (top – center – bottom) relates to the direction in which the portrayed person is looking. But what I am concerned with above all else is an aspect of these works which in my opinion addresses a specific problem: the problem of art.

Baldessari's choice of certain forms of representation and certain systems of signs and symbols for the three objects is by no means arbitrary. The denotative, classificatory use of just language for the animals is "apt" – in an ironic sense – in the context of the growing general unease about the unethical, purely profit-oriented way animals are treated. The photographs are an "apt" choice for the kind of appreciation of beauty which, in the plant kingdom, is particularly receptive to those plants which are not (yet) all that familiar, exotic plants, that is. Here photography simultaneously shows and celebrates them. As for the heads, they immediately conjure up the iconoclastic past, prohibitions against images, the undepictability of the human being. Thus Baldessari has sought, and found, a "higher" form, not one of pure depiction or representation but, rather, art itself, visualizing this undepictability anew by representing it as arbitrariness of form, as the style a great master.

And whilst the choice of systems is altogether "apt", it is nevertheless decidedly purposeful, and recognizably so. The discussed aspects of these systems and their implementation are not – and this is, I think, important – the result of an abstract, isolated process but, rather, closely bound up with

Auf diesen Gedanken reagiert Baldessari nun, indem er die Kunst – als Zitat – symbolisch in ein Format gleichberechtigt neben zwei anderen Systeme einschließt und sie darin der Permutierbarkeit, dem Platzwechsel, aussetzt. Dies geschieht in einer Arbeit, in der gerade Format und Träger in besonders auffälliger Weise im Sinne der referierten Idee künstlerisch bestimmt worden sind. Der Gedanke wird also einerseits in Zweifel gezogen, indem sozusagen vorgeführt wird, wie es möglich ist, mithilfe der Operation, die Kunst von jeder anderen Bildproduktion unterscheiden soll, Kunst zu symbolisieren und auch abzuwerten und zu relativieren. Andererseits operiert die Arbeit natürlich mit der u. a. auch durch Festlegung von Träger und Format erworbenen Autorität von Kunst, um Kunst-als-Ganzes zu symbolisieren und legitim eine Aussage darüber machen zu können.

Baldessari thematisiert also deutlicher denn je den Sonderfall "Kunst" unter den Bilderproduktionen, aber eben als ein Fall von Bildproduktion und Repräsentation. Nun sind alle Beispiele von Malerei in der Elbow-Serie aber von Goya, dem alten Gesprächspartner von Baldessari bei Text-Bild-Problemen. Goya, dem einerseits ein "politischer", andererseits ein "anthropologischer" Realismus nachgesagt wird, steht in der populären Vorstellung der Erkenntnis einer conditio humana, menschlicher Abgründe, aber auch Aufbrüche nahe, die noch heute in jeder emphatischen Anrufung des "Menschen" anklingen. Gleichwohl sind sie alt und als solche kenntlich. Der Mensch taucht also – folgen wir der Idee, daß die Wahl der Repräsentationssysteme irgendwie "paßt" – nur noch im Präteritum auf, mit ihm die Kunst. Nur noch Inkjet vermag ihn und sie in die technologische Gegenwart zu blasen.

Mit der Benennung dieser Leerstelle verweist Baldessari einerseits darauf, daß eine Entsprechung zu "Kunst" heute nicht zu finden ist. Zu vieles und zu weniges käme in Frage, eine "wahre" Kunst ließe sich nicht finden, die Vielfalt selbst ist nicht repräsentierbar. Andererseits ist die Leerstelle einer immer noch einigermaßen klar beschreibbaren gesellschaft-

discussions that are taking place today, and in this essay, too. Man/painting/art are clearly parts of a hierarchy of forms of representation within which animal/lettering and plant/photo, whilst being difficult to categorize out of context, readily find a place. Indeed, hierarchies are what this series of works is all about: the places are interchangeable and "level pegging" is also possible.

One idea that crosses my mind, although it is not new, neither in Baldessari's work nor in the post-conceptual debates, is that art differs from all other kinds of image production and, possibly, justifies itself not least by the fact that, in the case of a painting, for example, it determines the nature and size of the support. Consequently, this determining act is one of the parameters of the actual creative process. It is not Weiner's famous instructions, not ideas, not concepts, that are of decisive importance but, rather, the overriding decision concerning size, support, material, medium, technique etc. And although art is, by its very nature, artistic and therefore non-industrial, it may nevertheless utilize every conceivable industrial technique.

Baldessari now reacts to this idea by symbolically placing art – as a quotation – alongside two other systems in one and the same work, giving them complete equality and thus exposing them to endless possible permutations. Moreover, all this takes place in a work whose support and size have been determined artistically, in the above-defined sense, and in a particularly obvious way. Thus, on the one hand, Baldessari casts doubt on the idea by showing that it is possible, using the very operation with which art can be distinguished from every other kind of image production, to symbolize art, and also to belittle it and to relativize it. On the other hand, the work naturally operates with the authority of art, an authority acquired not least by virtue of its determining function as regards its support and size, in order to symbolize art-as-a-whole and to make a legitimate statement about it.

lichen Einrichtung "Kunst" und mit ihr einer privilegierten Sprechposition durchaus vorhanden. Sie kann einstweilen nur durch eine Umschreibung – Gegenwart dessen, was Goya für eine Vergangenheit repräsentiert – angegeben werden, die dem "Das!" aus den Bildunterschriften ähnelt, aber gleichzeitig natürlich dazu einlädt, die Vorzüge der privilegierten Sprecherposition zu überdenken.

Er macht da verschiedene Angebote. Zum einen stellt er sich selbst als einen Vertreter einer für Goyas Überlegungen satisfaktionsfähigen Praxis dar, er offeriert sein Modell als einen Vorschlag, diese Position als eine Position der Kritik wie der Analyse der restlichen Bilderwelt anzusehen. Zum anderen problematisiert er dieses Privileg und sein Sich Verlassen darauf, indem er es als eine Variable unter vielen Darstellungsmöglichkeiten relativiert – die ganz leicht mit den anderen den Platz tauschen kann.

Vor allem aber, und das ist das wichtigste, demonstriert Baldessari all dies mit sehr eindeutigen und dennoch rein visuellen Mitteln, die visuellen Mittel übernehmen ganz den Job der Formulierung von Paradoxa. Doch tun sie dies selber paradoxal, indem sie sich einer Rhetorik bedienen, die auf die Zuarbeit von Sprache, ihrem Iuxtapositionsstil und -regeln angewiesen ist. Und dennoch das Wort überhaupt nur einmal, als Etikett mit einem Tiernamen, braucht. Dies ließe sich auf die Formel bringen, daß Baldessari denkbar macht, daß die visuelle Kunst – also diejenige visuelle Praxis, die Träger, Ort, Technik etc. präzise festlegt – Kritik an (anderen) Bildern deswegen besser formulieren kann als ein Text, weil sie wohl einerseits dasselbe kann wie ein Text (rhetorisch sein, gegenüberstellen, ironisch sein, bewerten), aber andererseits anders als der kritische Text immer ihr Angewiesensein auf (leise) Ergänzungen offenlegt, sich immer wieder unter das Material mischt, über das sie sich als Kritik erhebt. Was der Text, weil es ihm dafür an Operatoren in der Regel gebricht, nicht kann. Daß Bild und Text nicht essentialisierbar sind, daß sie immer aufeinander angewiesen sind, komplementär – all

Whilst Baldessari here thematizes more clearly than ever the special position occupied by art in relation to other kinds of image production, the theme is, seemingly, just that: image production and representation. All the examples of painting in the "Elbow Series", however, are taken from Goya, Baldessari's old interlocutor in his text-and-image works. Now popular belief has it that Goya, who is said to have been both a "political" and an "anthropological" realist, had visions of the conditio humana, of the depths to which the human being can sink, and also of new awakenings which, even today, still find an echo in every emphatic appeal to "mankind". But be that as it may, they are old, and recognizable as such. Thus the human being appears – if we pursue the idea that Baldessari's choice of systems is "apt" – only in the past tense and, with him, art. Only ink-jet, nothing else, can blow him and it into the technological present.

The present "void" is Baldessari's way of saying that, today, "art" has no counterpart. Too much, and too little, would have to come under consideration. "True" art could never be found, and the very diversity of possibilities would be overwhelming. On the other hand, the "void" can indeed be filled today by the still relatively clearly definable social institution of "art" which, ipso facto, would also enjoy the privileged position of the orator. It can for the time being be described only by circumlocution – the present of what, for Goya, is the past – this being similar to the "it!" of the captions but naturally inviting us at the same time to consider the privileges of the orator's position.

Here Baldessari offers us various possibilities. On the one hand, he himself offers himself as the exponent of a method capable of realizing Goya's ideas satisfactorily, whereby he suggests using this position as one from which he can criticize and analyze the rest of the world of images. On the other, he expounds the problems of this privilege and his reliance on it by relativizing it as a variable among many possible forms of representation, a variable which can readily change places with the others.

das kann ein Text zwar im Ausnahmefall sagen, ein Bild weiß und zeigt es zu jeder Zeit.

Das wäre also ein Beispiel der Grundlagenforschung, die ich unter meiner dritten These angesprochen hatte. Sie besteht aus solchen klaren, aber vielschichtigen Versuchsanordnungen, deren entgegengesetztes Gegenüber wie auf primärer Ebene poetisch wirkende Arbeiten wie "Potatoes, Face (Smiling), Garbage Can, Landscape, Four Shapes + Red and Green Lines" oder "Flying Saucer: Rainbow/Two Cyclists/Dog/Gorilla and Bananas/Chaotic Situation/Couple/Tortoise/Gunman (Fallen)" oder "Arrive (With Motives and Reasons)" darstellen, die ganz stark der Untersuchung des Bilder Machens/Sehresultate Erbeutens gewidmet sind. Sie, meine Leserinnen und Leser, wird dieses Ergebnis meines Essays nicht überraschen. Ich halte die Kunst für einen potentiellen Ort der Kritik. Und zwar der Kritik aller Bilder. Ihr privilegierter Ort ist nur noch darüber zu rechtfertigen, daß sie der einzige Ort ist, von dem aus man Bilder als solche und als visuelle Daten in Bezug zu ihren Grenzen und Nebengebieten (Sprache, Klassifikationssysteme, Repräsentation etc.) sammeln, bearbeiten, analysieren und die Kritik ihres Alltagsgebrauchs als eine Kritik des Bilder-Machens formulieren kann, nämlich in Bildern. Diese Bilder können dann wieder Material für rein sprachliche Diskurse bilden, denen fehlt aber die Vorsortierung und das Vorverständnis durch eine privilegierte Bildkritik. Die wird heutzutage durch die Fülle neuartiger und extrem fluider Bilder um so wichtiger. Diese Kunst-als-Bilderkritik steht als Kritik natürlich nochmal auf einer weiteren Ebene (nicht nur auf der, auf der Bilder dieses Problem haben) in einem problematisch-prekären Verhältnis zu Sprache und Text und muß dieses Verhältnis austragen. Das Problem der Post- und Neo-Konzeptualisten, ohne einen Bildbegriff zu arbeiten, und der Visual Culture, auf jedweden Kunstbegriff zu pfeifen, haben gute kritische Künstler längst hinter sich gelassen. Kaum einer hat das Programm allerdings schon so lange erfolgreich betrieben wie John Baldessari.

What is most important, however, is the fact that Baldessari demonstrates all this with very unambiguous, though purely visual means. These visual means fully assume the task of expressing paradoxes. But they themselves do this paradoxically, for they use a rhetoric which relies on the assistance of language, of its style and rules of juxtaposition. And yet it needs the word, just once, as a label bearing the name of an animal. It is a kind of formula with which Baldessari demonstrates that visual art – that is to say, the kind of art that determines the support, size, place, technique etc. – is better able to criticize (other) images than a text because, on the one hand, it can do exactly the same things as a text (it can be rhetorical, it can juxtapose, it can be ironical, it can evaluate etc.) and, on the other, it differs from the critical text inasmuch as it always reveals its reliance on (slight) amplification, mingling with the very material to which it, in its capacity as a critic, is superior. And this is precisely what the text cannot do because, as a rule, it lacks the operational means. That image and text cannot be essentialized, that the one always has to rely on the other, complementarily, can indeed be said by a text in exceptional cases; an image knows and shows this at all times.

This might serve as an example of the basic research mentioned in the third of my above-expounded theses. It involves a clear yet complex approach to such works as "Potatoes, Face (Smiling), Garbage Can, Landscape, Four Shapes + Red and Green Lines" or "Flying Saucer: Rainbow/Two Cyclists/Dog/Gorilla and Bananas/Chaotic Situation/Couple/Tortoise/Gunman (Fallen)" or "Arrive (With Motives and Reasons)" which, whilst being seemingly poetical, largely investigate the processes of image production and capture. You, dear readers, will not be surprised by the result arrived at in my essay. I consider art to be a potential place of criticism, criticism of all images. It is a privileged place, but only because it is the only place where images as such and images as visual data can, with reference to their limitations and secondary fields (language, classification systems, repre-

Schließlich gingen wir einmal früh am Nachmittag am Haus der Vicomtesse vorbei vom Strand weg und kehrten später in einer kleinen Gastwirtschaft ein. Es gab hier einen Kicker-Automaten, der sehr sehr alt aussah, aber wenn man ihn betrieb, hatte er eine Lautsprecherautomatik eingebaut, die jeweils einen der beiden Spieler als "Sporting" oder "Benfica" anfeuerte. Ich war "Benfica" und verlor und durch die ganze Wirtschaft brüllte es "Sporting, Sporting!" Hier entdeckten wir nun Baldessari auf der Terrasse und hätten ihn fast nicht erkannt. Seine Arme waren entblößt, und er las eine französische Zeitung (Wo hatte er die her?). Er trank große Mengen Bier, und sein Gesicht war ganz und gar verändert. Es war nur noch der Bart, der ähnlich war, die muskulösen rötlichen Arme und alles andere – das waren viele neue störende Eindrücke, gegen die das Gesicht nun schon große Anstrengungen der Ähnlichkeit hätte unternehmen müssen. Wir tranken zwei kleine Bier und zogen von dannen.

sentation etc.), be gathered, processed and analyzed, the only place where criticism of their everyday use can be formulated as criticism of image production, namely in images. These images may indeed serve as material for purely linguistic discourse, but this discourse lacks that pre-sorting and pre-understanding capacity that is the privilege of image criticism. This aspect has become even more important in the present-day context on account of the flood of new and extremely fluid images that now inundates us. Naturally, art as image criticism also operates on another level, too, not just the one on which the images have this problem, namely on that level of the precarious relationship between language and text, and must address the problems that this relationship involves. Good critical artists have long since gotten over the problem of the Post- and Neo-Conceptualist camp of working without an image concept and that of the Visual Culture camp of renouncing every concept of art. Hardly any other artist has operated the program for as long and as successfully as John Baldessari.

In the end, early one afternoon, we left the beach and strolled past the vicomtesse's residence, eventually stopping for a drink at a small restaurant. We played on an automatic soccer machine, which looked very, very old, but it had a built-in automatic loudspeaker which cheered on each of the two players, shouting the names of the soccer teams: "Sporting!" and "Benfica!" I was "Benfica" and lost the game, whereupon the entire restaurant was filled with the roar of the loudspeaker: "Sporting, Sporting!" Abandoning the game, we went out onto the terrace, where we discovered Baldessari, though we hardly recognized him. His arms were bare and he was reading a French newspaper (where had he managed to get it?). He was drinking one beer after another and his face had changed completely. Only the beard was the same. His muscular, reddish arms and everything else conveyed so many new and disturbing impressions that his face would have had to make the utmost effort to look similar. We drank two beers and went our way.

1 Benjamin Buchloh, Periodizing Critics, in Dia Art Foundation/Hal Foster (Hg.), Discussions in Contemporary Culture, Number 1, Seattle: Bay Press 1987, S. 65–69

2 Irit Rogoff, The Aesthetics of Post-History, in Stephen Melville/Bill Readings (Hg.), Vision and Textuality, Durham: Duke University Press 1995, S. 121 f.

3 Ich ignoriere hier die vielfältigen (sprach-)philosophischen Implikationen des Problems und auch die Unterschiede zwischen sprachlicher Bestimmung durch den Betrachter, Titel und Bildunterschrift, weil es mir um die bei Baldessari angesprochenen benennbaren oder adressierbaren sprachlichen Anteile oder Krücken geht, die in jedem Bilderschließungsprozeß jenseits rein subjektiver Vorgänge enthalten sind.

1 Benjamin Buchloh, Periodizing Critics, in Dia Art Foundation/Hal Foster (ed.), Discussions in Contemporary Culture, Number 1, Seattle: Bay Press 1987, p. 65–69

2 Irit Rogoff, The Aesthetics of Post-History, in Stephen Melville/Bill Readings (ed.), Vision and Textuality, Durham: Duke University Press 1995, p. 121 f.

3 Here I am ignoring the diverse philosophical (language-related) implications of the problem, and also the differences between the linguistic interpretations of the viewer and those suggested by the titles and captions, because I am concerned in Baldessari's work primarily with those namable or addressable linguistic components or props which operate in every image exploring process on a level higher than the purely subjective one.

Works 1988–1999

SIX WAYS
TO PRONOUNCE FIDDLESTICK
(For L. Sterne)

1988

Ölfarbe auf Silbergelatinefotografien,
aufgezogen auf Aluminium/
Oil stain on gelatin silver photographs
mounted on aluminium

305 x 406 cm/120 x 160 inches

Courtesy Sonnabend Gallery, New York,
and Massimo Martino Fine Arts & Projects,
Mendrisio

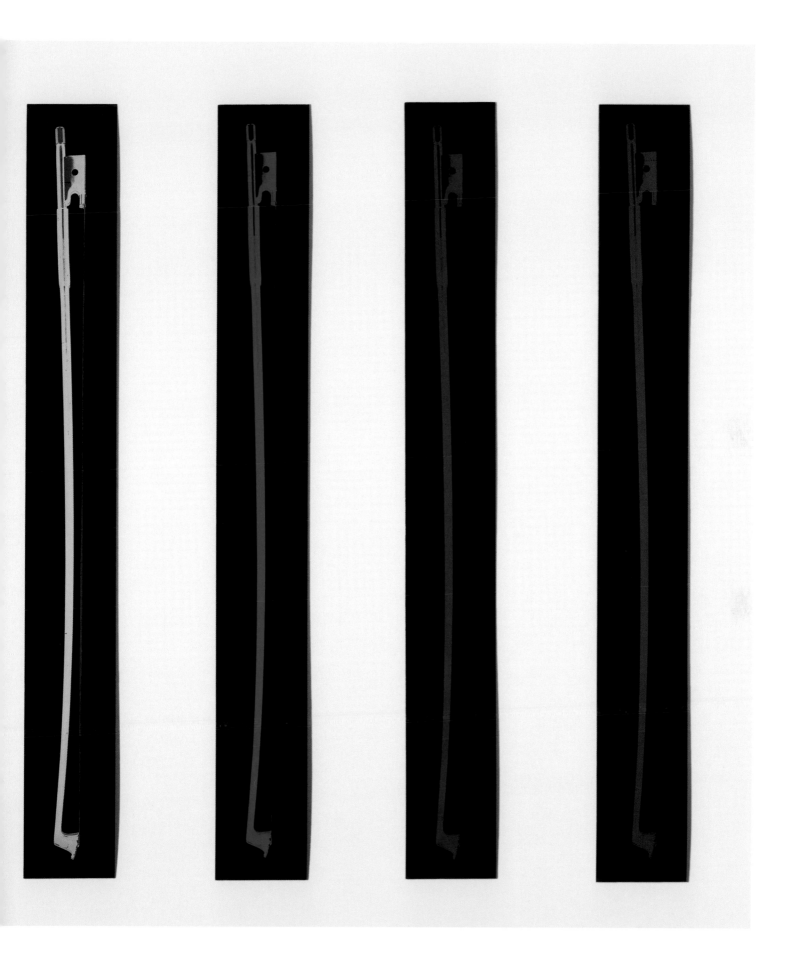

MAN RUNNING/MEN CARRYING BOX

1988–90

Schwarzweißfotografien, Vinylfarbe, Ölfarbentönung/
Black and white photographs, vinyl paint, oil tint

123 x 268 cm/48 x 105 inches

Sprengel Museum Hannover/Sammlung Siemens Kulturprogramm

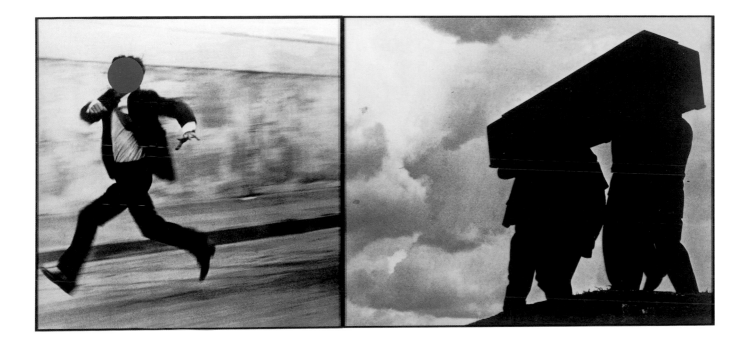

THREE ACTIVE PERSONS /
WITH STANDING PERSON

1990

Farbfotografien, Vinylfarbe/
Color photographs, vinyl paint

234 x 147 cm/92 x 58 inches

Courtesy Sonnabend Gallery, New York

TWO VOIDED BOOKS

1990

Schwarzweißfotografien, Vinylfarbe/
Black and white photographs, vinyl paint

157 x 245 cm/62 x 96.5 inches

Courtesy of Margo Leavin Gallery, Los Angeles

Photograph © Douglas M. Parker Studio

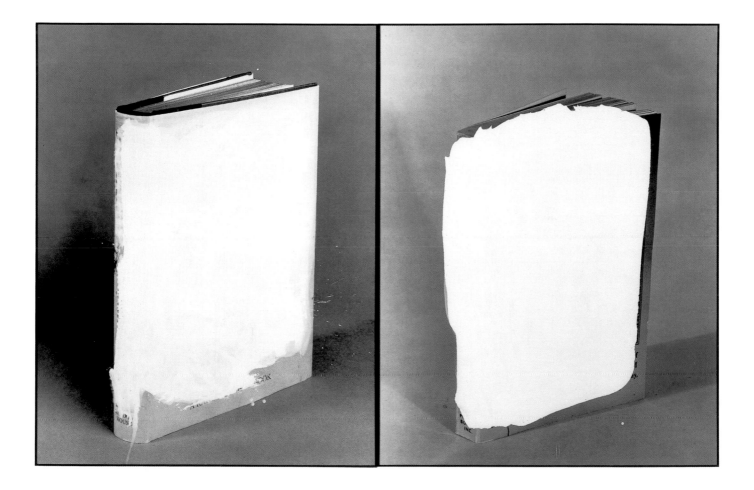

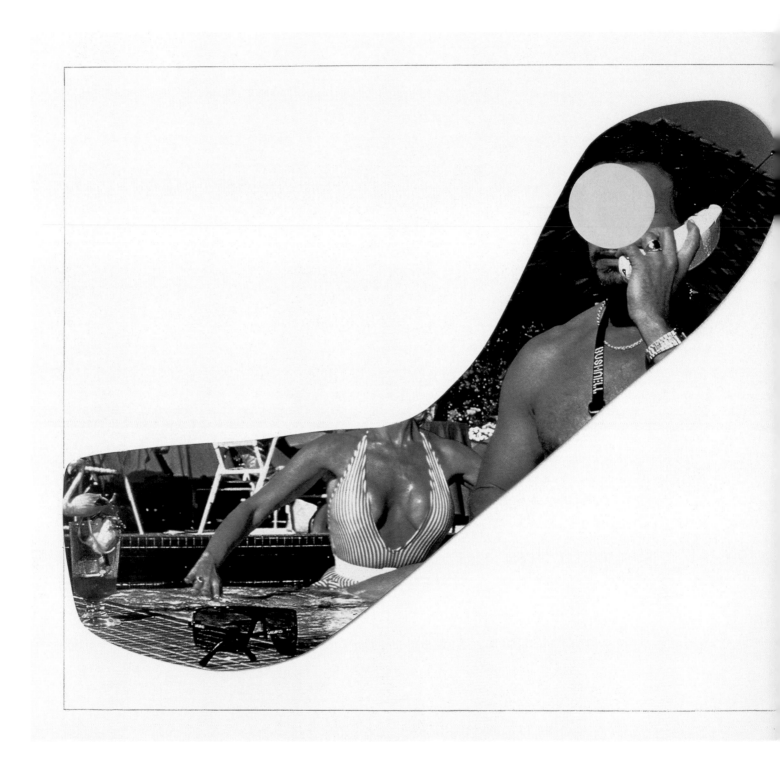

TELEPHONE
(FOR KAFKA)

1991

Farbfotografie, Schwarzweiß-
fotografie, Vinylfarbe/
Color photograph, black and
white photograph, vinyl paint

243,84 x 487,68 cm/
96 x 192 inches

Courtesy Sonnabend Gallery,
New York

FOUR FABRICS (PATTERNED):
TWO GLASSES/PASSERS-BY

1992

Farbfotografien, Schwarzweißfotografien, Ölfarbentönung, auf Masonite/
Color photographs, black and white photographs, oil tint, Masonite

250 x 219 cm/98.5 x 86.25 inches

Courtesy Mai 36 Galerie, Zürich

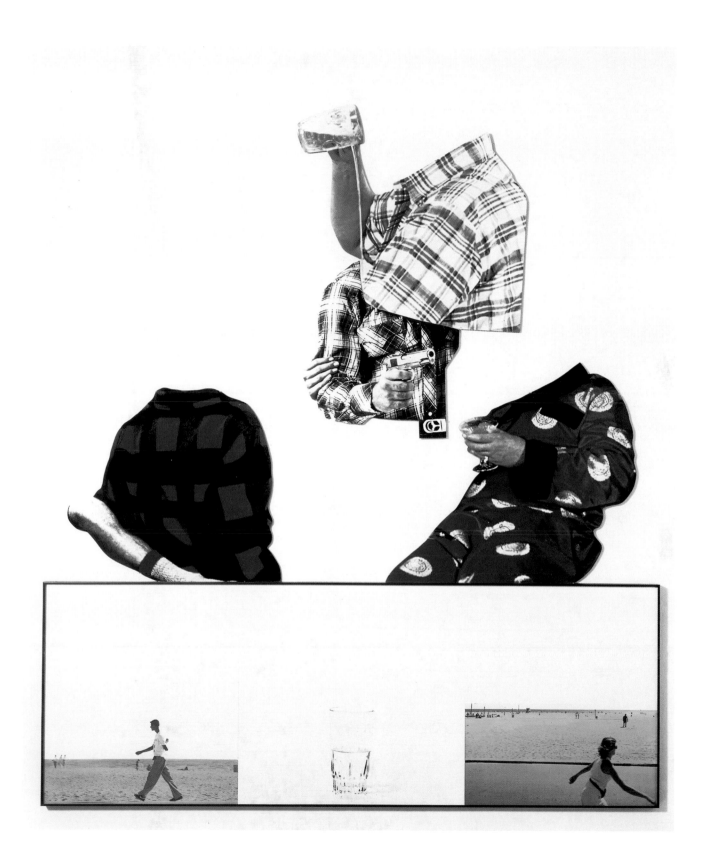

THE PHONE CALL: FACELESS MAN (ORANGE)
WITH GLASSES / ENTANGLEMENT OF WORMS

1992

Farbfotografien, Acrylfarbe, Zeichenkreide/
Color photographs, acrylic paint, crayon

203 x 119 cm/80 x 47 inches

Courtesy Sonnabend Gallery, New York

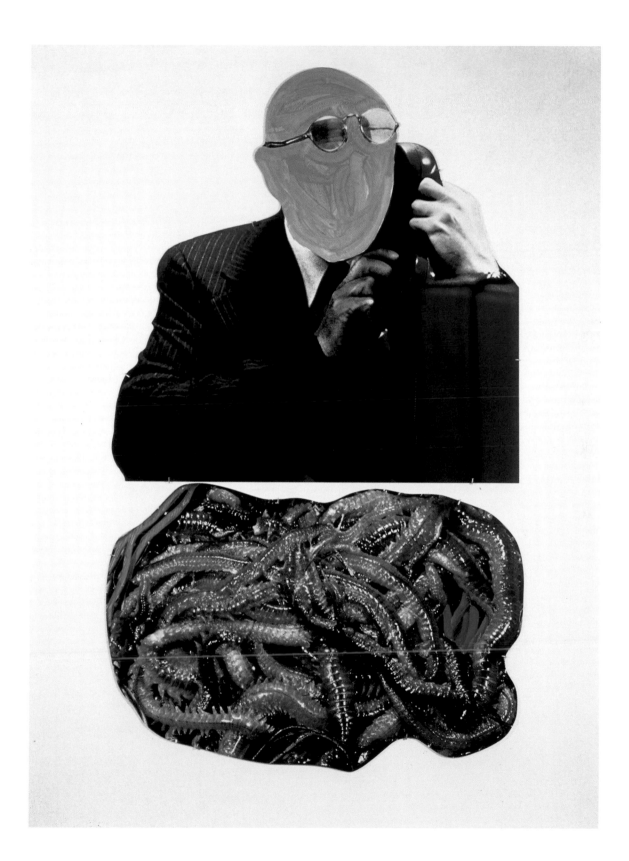

FLYING SAUCER: RAINBOW/TWO CYCLISTS/
DOG/GORILLA AND BANANAS/CHAOTIC SITUATION/
COUPLE/TORTOISE/GUNMAN (FALLEN)

1992

Farbfotografien, Schwarzweißfotografien, Acrylfarbe, auf Masonite/
Color photographs, black and white photographs, acrylic paint, Masonite

259 x 411 cm/101 x 162 inches

Courtesy Sonnabend Gallery, New York

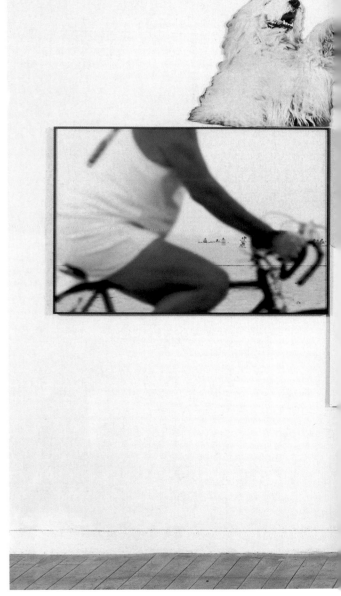

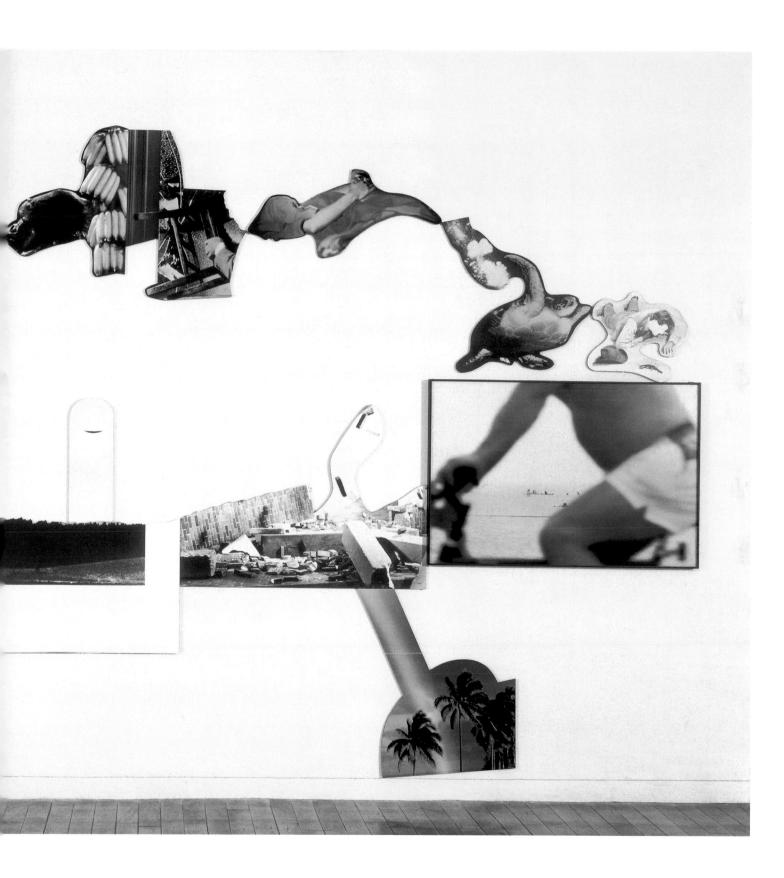

MAN WITH HANDLEBAR MUSTACHE/
TWO BRANCHES (WITH BLACK INTRUSION)

1992

Farbfotografie, Schwarzweißfotografie, Fotokopie auf Gandhi Ashram Papier,
Acrylfarbüberzug, Papieraufkleber, Zeichenkreide, Ölfarbe auf Gummi,
Ölfarbe auf Resopal, aufgezogen auf Masonite/
Color photograph, black and white photograph, photocopy on Gandhi
Ashram paper, acrylic wash, paper stickers, crayon, oil enamel on rubber,
oil enamel on formica, mounted on Masonite

210 x 249 cm/82.5 x 98 inches

Courtesy Sonnabend Gallery, New York

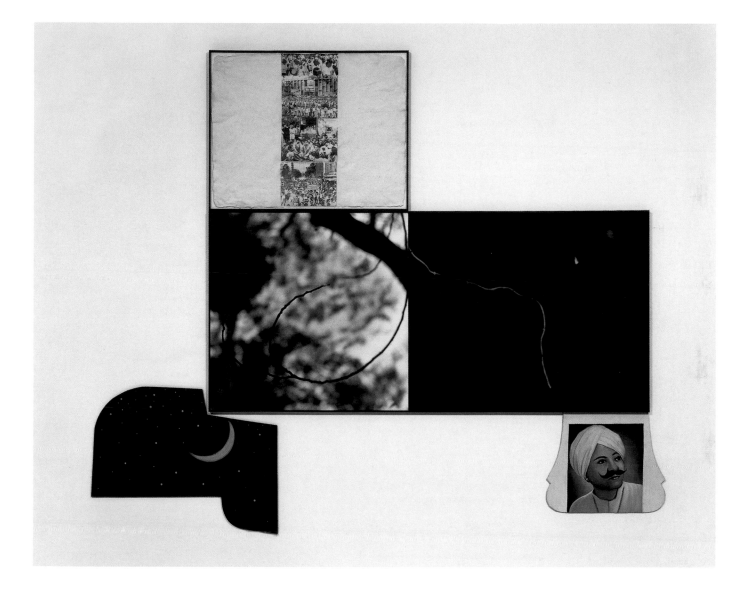

POTATOES, FACE (SMILING),
GARBAGE CAN, LANDSCAPE, FOUR SHAPES +
RED AND GREEN LINES

1994

Farbfotografie, Schwarzweißfotografie, Acrylfarbe, Ölpastellfarbe
und Bleistift auf Papier /
Color photograph, black and white photograph, acrylic, oil pastel
and pencil on paper

166 x 215 cm / 65.25 x 84.75 inches

Courtesy Sonnabend Gallery, New York

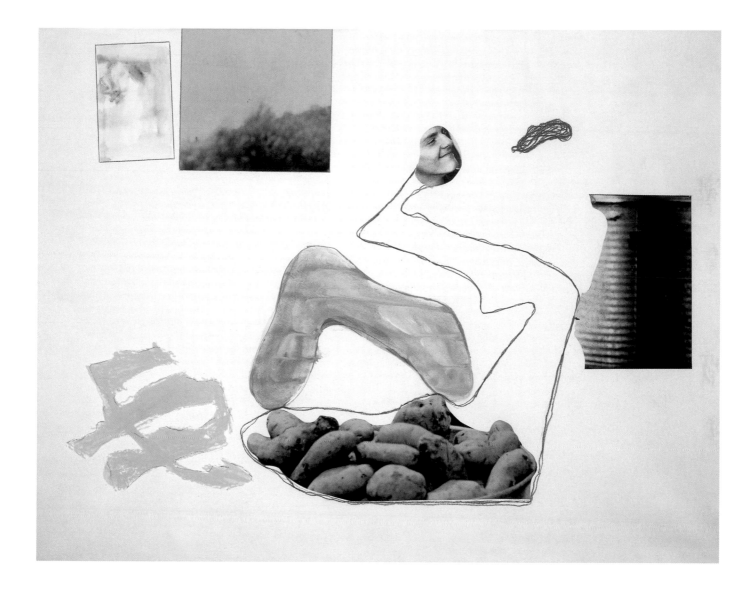

POINTING HAND, DESK, LIGHTS,
AND OBSERVERS (COURTROOM)

1995

Schwarzweißfotografien, Farbfotografien, Acrylfarbe,
Ölkreide, Bleistift auf Papier/
Black and white photographs, color photographs, acrylic, oil stick,
pencil on paper

255 x 229 cm / 100.5 x 90.25 inches

Courtesy of Margo Leavin Gallery, Los Angeles

Photograph © Douglas M. Parker Studio

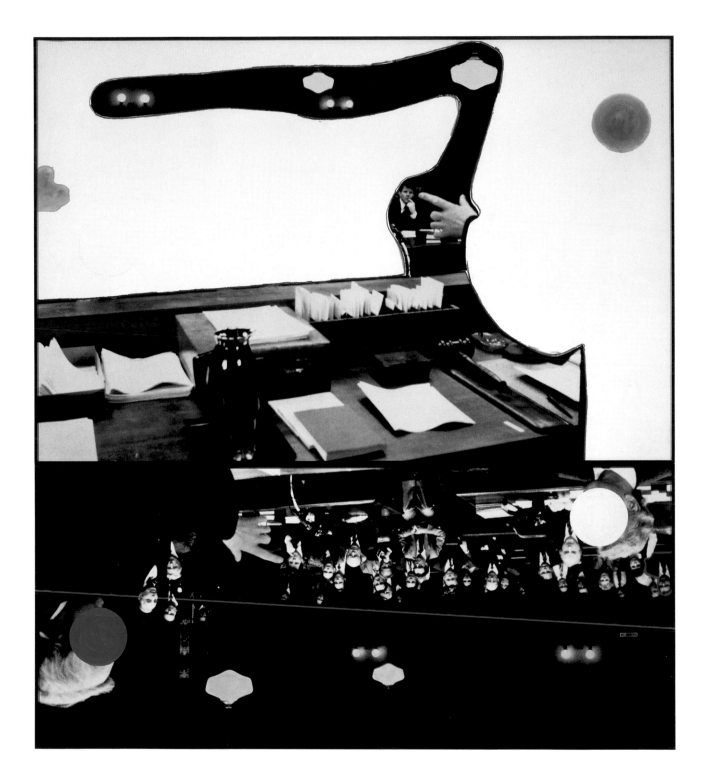

THREE RUNNING FIGURES (ONE SPLASHED),
TRASH CANS, AND POLES (WITH LARGE BLUE SHAPE)

1995

Schwarzweißfotografien, Farbfotografien, Acrylfarbe, Ölkreide, Bleistift auf Papier/
Black and white photographs, color photographs, acrylic, oil stick, pencil on paper

193 x 106 cm/76 x 41.75 inches

Courtesy of Margo Leavin Gallery, Los Angeles

Photograph © Douglas M. Parker Studio

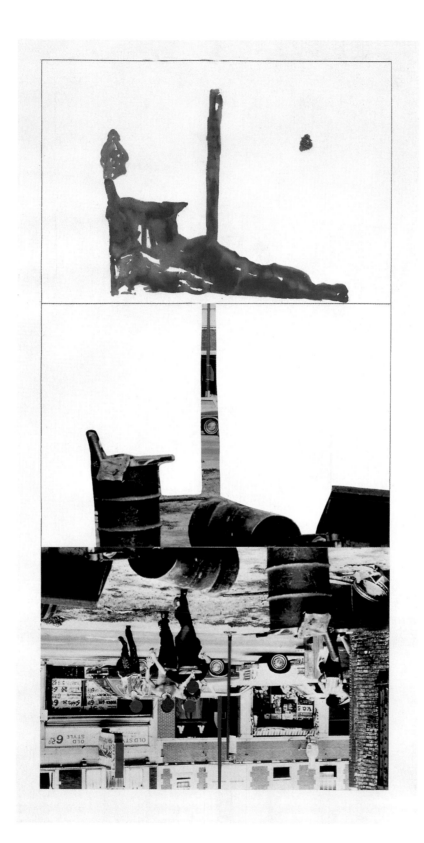

SUNNY DONUTS,
724 HIGHLAND AVENUE,
NATIONAL CITY, CALIF.

1996

Acrylfarbe und Ink-jet auf Leinwand/
Acrylic and ink-jet on canvas

150 x 114 cm/59 x 45 inches

Courtesy Mai 36 Galerie, Zürich

Photograph © Philipp Scholz-Rittermann,
San Diego

FORMER SITE OF DUCK POND BAR,
3003 NATIONAL CITY BLVD.,
NATIONAL CITY, CALIF.

1996

Acrylfarbe und Fotoemulsion auf Leinwand/
Acrylic and photoemulsion on canvas

150 x 114 cm/59 x 45 inches

Courtesy Philomene Magers – Monika Sprüth,
Munich/Cologne, and Sonnabend Gallery, New York

Photograph © Philipp Scholz-Rittermann,
San Diego

EARL SCHEIB AUTO PAINTING,
111 NATIONAL CITY BLVD.,
NATIONAL CITY, CALIF.

1996

Acrylfarbe und Fotoemulsion auf Leinwand/
Acrylic and photoemulsion on canvas

150 x 114 cm/59 x 45 inches

Courtesy Philomene Magers – Monika Sprüth,
Munich/Cologne, and Sonnabend Gallery, New York

Photograph © Philipp Scholz-Rittermann,
San Diego

LOURDES RESTAURANT,
1125 NATIONAL CITY BLVD.,
NATIONAL CITY, CALIF.

1996

Acrylfarbe und Fotoemulsion auf Leinwand/
Acrylic and photoemulsion on canvas

150 x 114 cm/59 x 45 inches

Courtesy Mai 36 Galerie, Zürich

Photograph © Philipp Scholz-Rittermann,
San Diego

1121 EAST SECOND STREET,
NATIONAL CITY, CALIF.

1996

Acrylfarbe und Fotoemulsion auf Leinwand/
Acrylic and photoemulsion on canvas

150 x 114 cm/59 x 45 inches

Courtesy Philomene Magers – Monika Sprüth,
Munich/Cologne, and Sonnabend Gallery, New York

Photograph © Philipp Scholz-Rittermann,
San Diego

PINK PIG, 2305 HIGHLAND AVE.,
NATIONAL CITY, CALIF.

1996

Acrylfarbe und Ink-jet auf Leinwand/
Acrylic and ink-jet on canvas

150 x 114 cm/59 x 45 inches

Courtesy Philomene Magers – Monika Sprüth,
Munich/Cologne, and Sonnabend Gallery, New York

Photograph © Philipp Scholz-Rittermann,
San Diego

STAR THEATER, 4762 RIDGEWAY
DRIVE, LINCOLN ACRES,
NATIONAL CITY, CALIF.

1996

Acrylfarbe und Fotoemulsion auf Leinwand/
Acrylic and photoemulsion on canvas

150 x 114 cm/59 x 45 inches

Courtesy Philomene Magers – Monika Sprüth,
Munich/Cologne, and Sonnabend Gallery, New York

Photograph © Philipp Scholz-Rittermann,
San Diego

SUNNY DONUTS
724 HIGHLAND AVENUE
NATIONAL CITY, CALIF.

LOURDES RESTAURANT
1125 NATIONAL CITY BLVD.
NATIONAL CITY, CALIF.

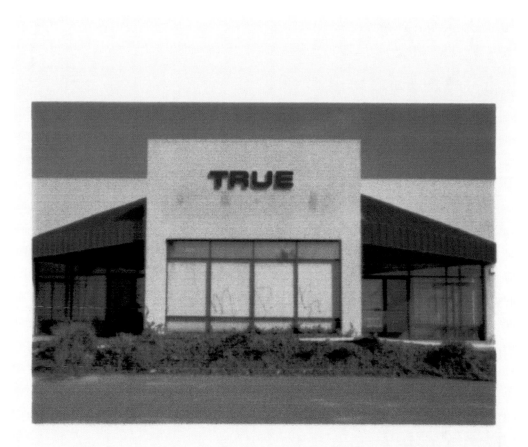

FORMER SITE OF DUCK POND BAR
3003 NATIONAL CITY BLVD.
NATIONAL CITY, CALIF.

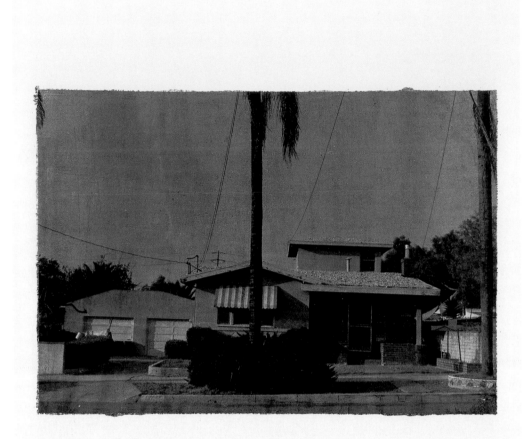

1121 EAST SECOND STREET
NATIONAL CITY, CALIF.

STAR THEATER
4762 RIDGEWAY DRIVE
LINCOLN ACRES, CALIF.

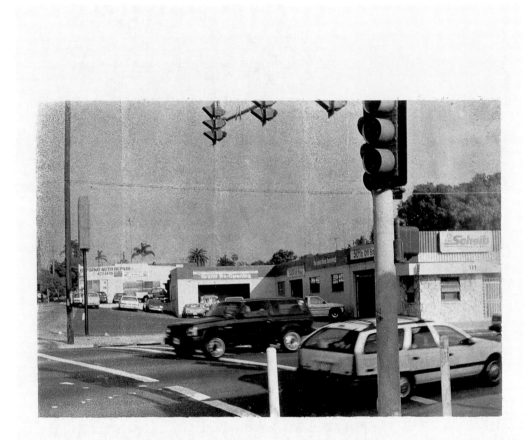

EARL SCHEIB AUTO PAINTING
111 NATIONAL CITY BLVD.
NATIONAL CITY, CALIF.

PINK PIG
2305 HIGHLAND AVE.
NATIONAL CITY, CALIF.

ARRIVE (WITH MOTIVES AND REASONS)

1996

Farbfotografien, Acrylfarbe und Zeichenkreide/
Color photographs, acrylic paint and crayon

235 x 327 cm/92.38 x 128.63 inches

Courtesy Sonnabend Gallery, New York, and Chaac Mool Gallery,
Los Angeles

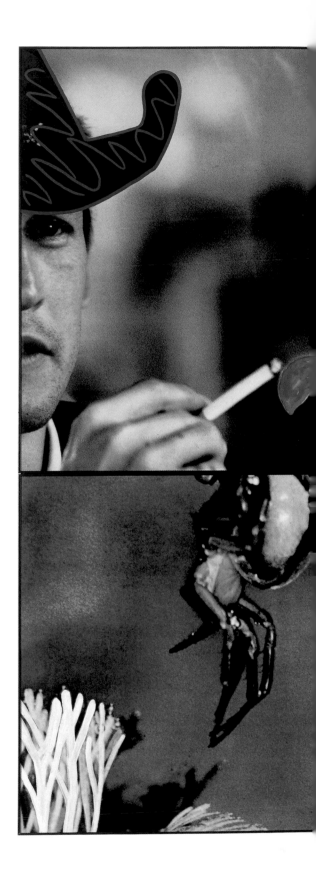

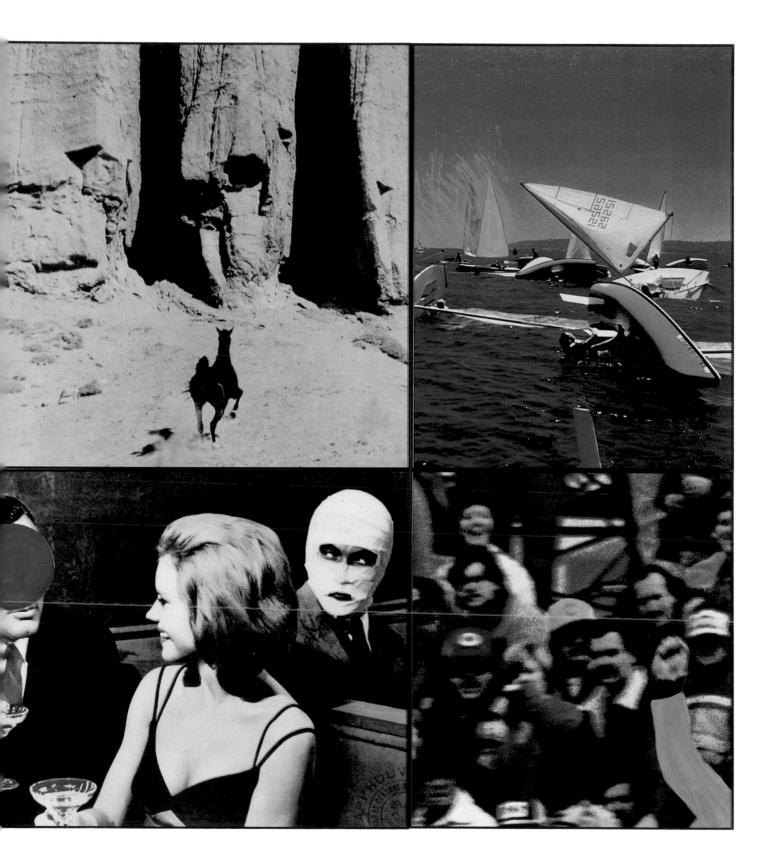

GOYA SERIES: THERE ISN'T TIME

1997

Ink-jet Print und handgeschriebener Text auf Leinwand/
Ink-jet print and hand lettering on canvas

190 x 152 cm/75 x 60 inches

Private collection, Stuttgart

Courtesy Kulturmanagement Häusler, Munich

GOYA SERIES: AS IS

1997

Ink jet Print und handgeschriebener Text auf Leinwand/
Ink-jet print and hand lettering on canvas

190 x 152 cm/75 x 60 inches

Courtesy Sonnabend Gallery, New York

GOYA SERIES: SO MUCH AND MORE

1997

Ink-jet Print und handgeschriebener Text auf Leinwand/
Ink-jet print and hand lettering on canvas

190 x 152 cm/75 x 60 inches

Courtesy Estelle Schwartz, New York

GOYA SERIES: AND

1997

Ink-jet und synthetische Polymerfarbe auf Leinwand/
Ink jet and synthetic polymer paint on canvas

190 x 152 cm/75 x 60 inches

The Museum of Modern Art, New York, Mr. and
Mrs. Thomas H. Lee Fund, 1998

GOYA SERIES: THESE TOO

1997

Ink-jet Print und handgeschriebener Text auf Leinwand/
Ink-jet print and hand lettering on canvas

190 x 152 cm/75 x 60 inches

Collection Per Ovin, Sollentuna, Sweden

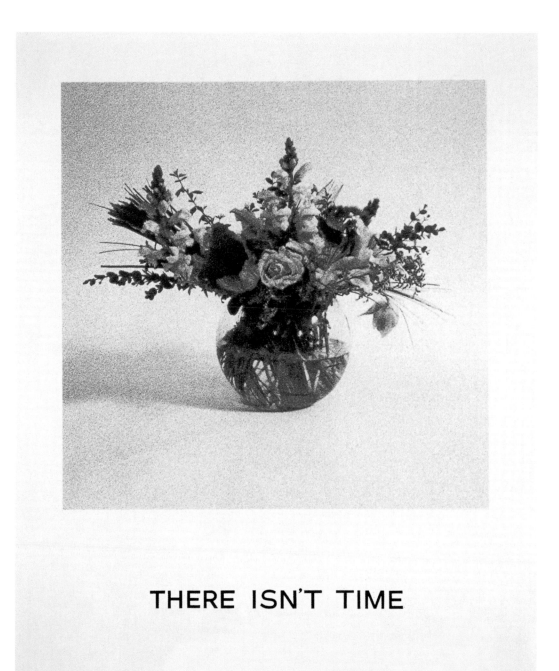

THERE ISN'T TIME

AS IS

SO MUCH AND MORE

AND

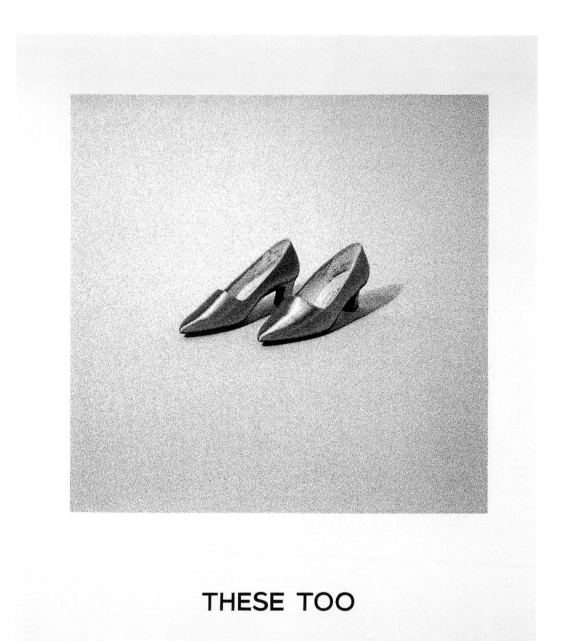

THESE TOO

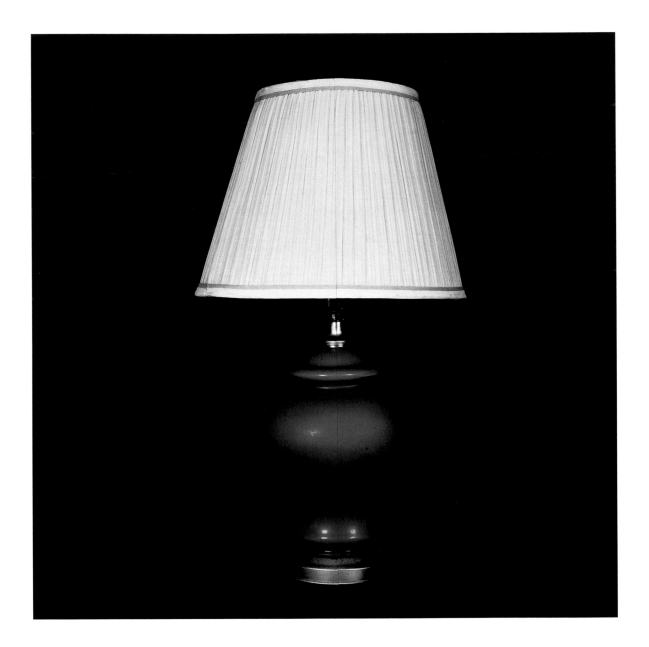

LAMP (ROTTERDAM #3), 1997–98

Schwarzweißfotografie/Black and white photograph

183 x 183 cm/72 x 72 inches

Courtesy Sonnabend Gallery, New York

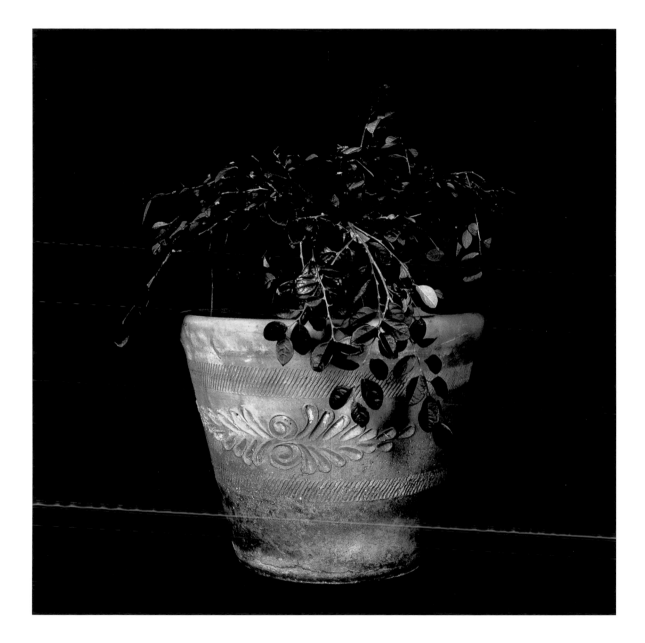

PLANT (ROTTERDAM #3), 1997–98

Schwarzweißfotografie/Black and white photograph

183 x 183 cm/72 x 72 inches

Courtesy Sonnabend Gallery, New York

Installation photograph of L A M P

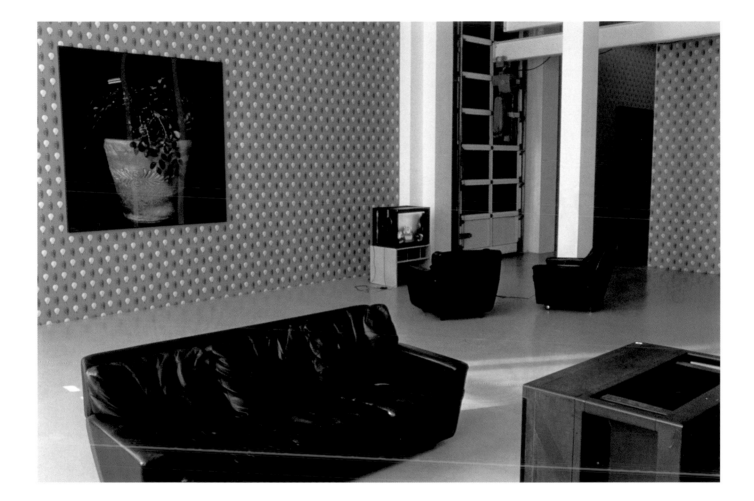

Installation photograph of P L A N T

ELBOW SERIES: EMU

1999

Ink-jet auf Leinwand, Folio D Prozeß auf Vinyl, handgeschriebener Text
und Acrylfarbe/
Ink-jet on canvas, Folio D process on vinyl, hand lettering and acrylic paint

213,5 x 213,5 cm/84 x 84 inches

Private collection - Courtesy Sonnabend Gallery, New York,
and Massimo Martino Fine Arts & Projects, Mendrisio

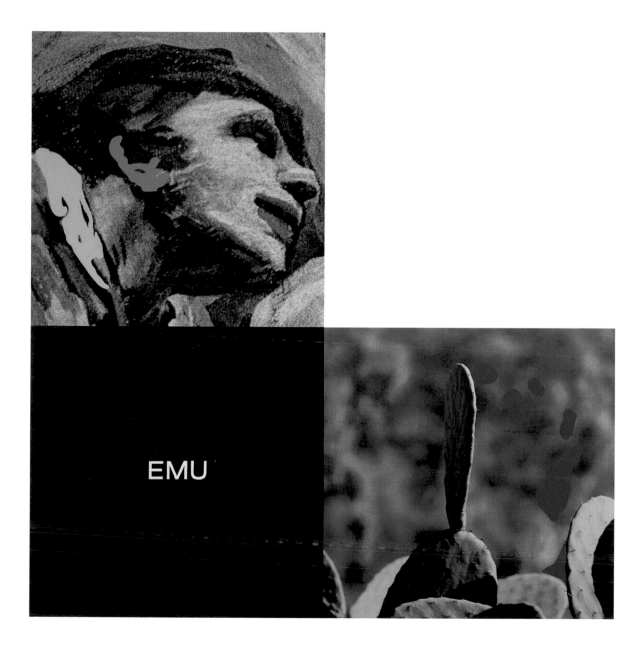

EMU

ELBOW SERIES: YAK

1999

Ink-jet auf Leinwand, Folio D Prozeß auf Vinyl, handgeschriebener Text
und Acrylfarbe/
Ink-jet on canvas, Folio D process on vinyl, hand lettering and acrylic paint

213,5 x 213,5 cm/84 x 84 inches

Courtesy Sonnabend Gallery, New York, and Massimo Martino
Fine Arts & Projects, Mendrisio

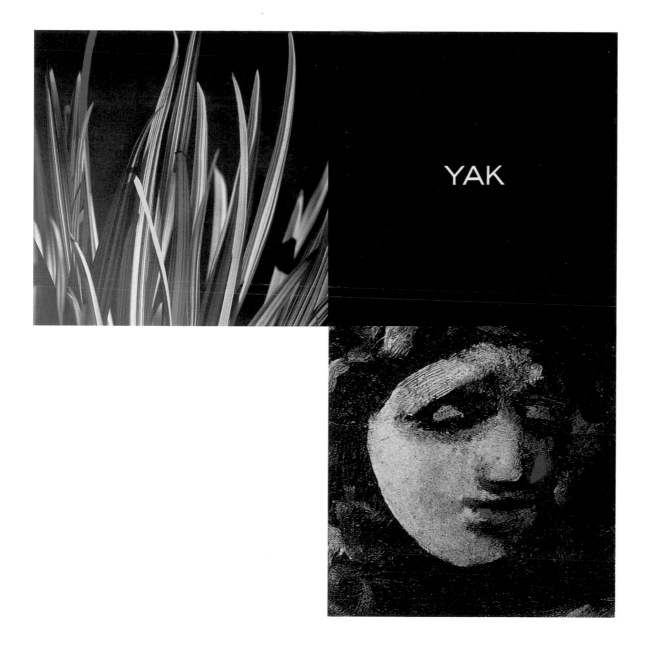

YAK

ELBOW SERIES: AUK

1999

Ink-jet auf Leinwand, Folio D Prozeß auf Vinyl, handgeschriebener Text
und Acrylfarbe/
Ink-jet on canvas, Folio D process on vinyl, hand lettering and acrylic paint

213,5 x 213,5 cm/84 x 84 inches

Courtesy Sonnabend Gallery, New York, and Massimo Martino
Fine Arts & Projects, Mendrisio

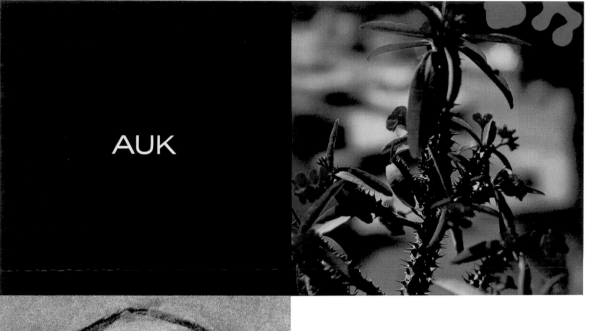

AUK

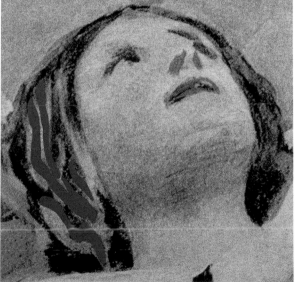

ELBOW SERIES: GNU

1999

Ink-jet auf Leinwand, Folio D Prozeß auf Vinyl, handgeschriebener Text
und Acrylfarbe /
Ink-jet on canvas, Folio D process on vinyl, hand lettering and acrylic paint

213,5 x 213,5 cm / 84 x 84 inches

Courtesy Sonnabend Gallery, New York, and Massimo Martino
Fine Arts & Projects, Mendrisio

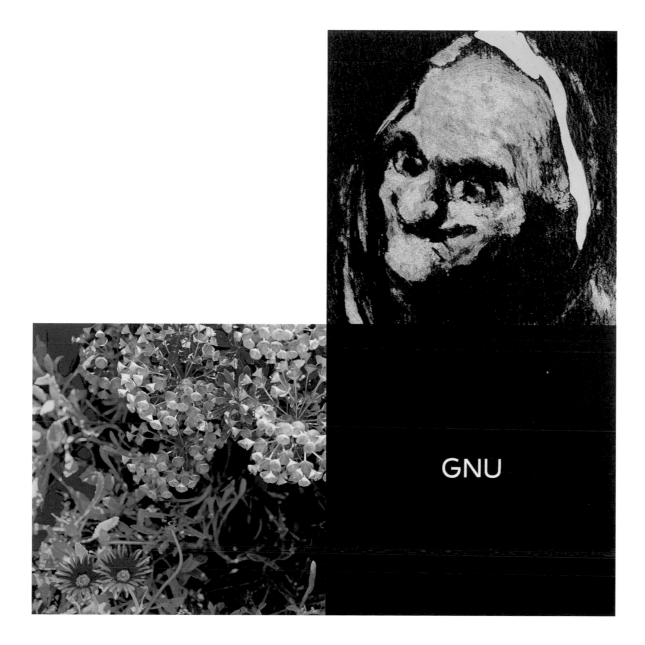

GNU

TETRAD SERIES: REAL SHADOWS

1999

Digitaldruck, handgeschriebener Text, Acrylfarbe auf Leinwand/
Digital printing, hand lettering, acrylic paint on canvas

239 x 239 cm/94 x 94 inches

Collection of Craig and Ivelin Robins, Miami Beach, FL
Courtesy Marian Goodman Gallery, New York, Paris

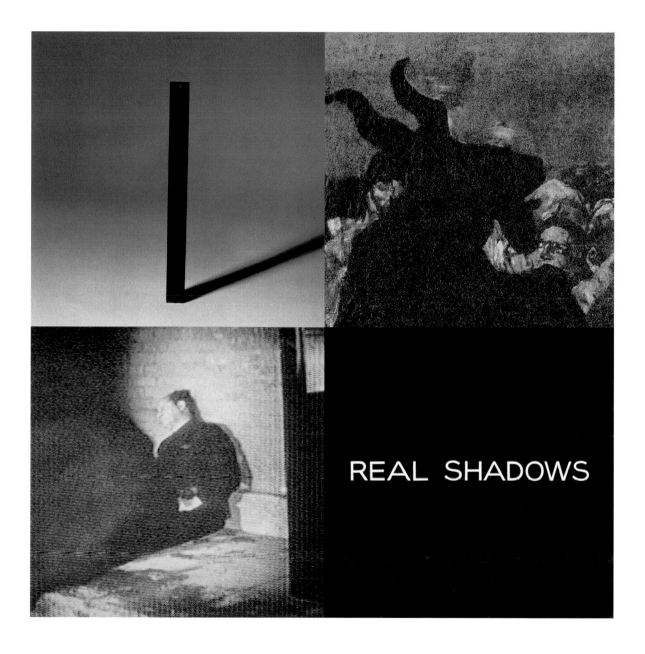

REAL SHADOWS

TETRAD SERIES: ALL GETTING ON TOGETHER

1999

Digitaldruck, handgeschriebener Text, Acrylfarbe auf Leinwand/
Digital printing, hand lettering, acrylic paint on canvas

239 x 239 cm/94 x 94 inches

Courtesy Marian Goodman Gallery, New York, Paris

Photograph © Cathy Carver, New York, NY

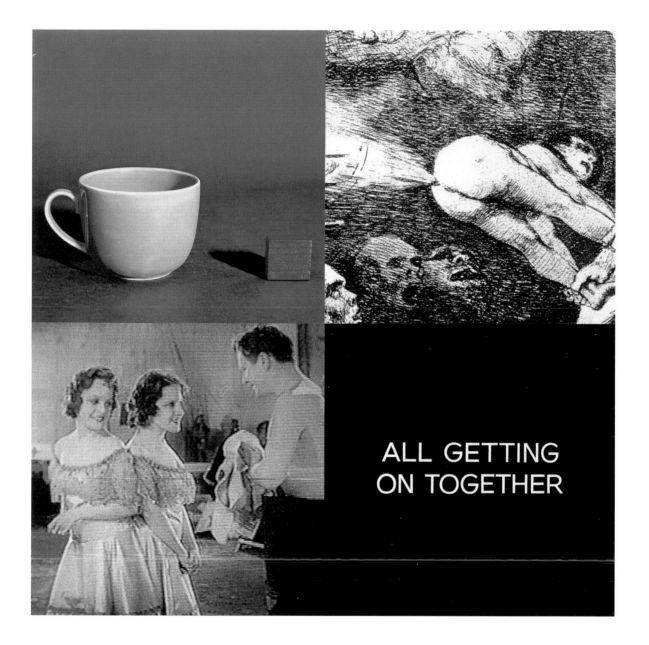

ALL GETTING
ON TOGETHER

Anhang/Appendix

Geboren/Born

National City, California, June 17, 1931

AUSBILDUNG/EDUCATION

1949–53
B.A., San Diego State College, California

1954–55
University of California at Berkeley, California

1955
University of California at Los Angeles,
California

1955–57
M.A., San Diego State College, California

1957–59
Otis Art Institute, Los Angeles, California
Chouinard Art Institute, Los Angeles,
California

Lives and works in Santa Monica, California

AUSZEICHNUNGEN/AWARDS

1999
Spectrum – International Award for Photo-
graphy of the Foundation of Lower Saxony,
Germany

College Art Associations Lifetime Achieve-
ment Award

1997
Governor's Award for Lifetime Achievement
in the Visual Arts, California

1996
Oskar Kokoschka Prize, Vienna, Austria

EINZELAUSSTELLUNGEN/ ONE-PERSON EXHIBITIONS
(Auswahl/Selection)

2000
BALDESSARI, "While something is hap-
pening here, something else is happening
there. Works 1988–1999", Staatliche Kunst-
sammlungen Dresden, Gemäldegalerie
Neue Meister, Dresden, Germany

1999
BALDESSARI, "While something is hap-
pening here, something else is happening
there. Works 1988–1999", Spectrum –
International Award of the Foundation
of Lower Saxony, Sprengel Museum
Hannover, Germany
"John Baldessari, The Tetrad Series 1999",
Marian Goodman Gallery, New York, NY
"Baldessari und Goya", Albertina im
Akademiehof, Vienna, Austria
"The Elbow Series 1999", Massimo Martino
Fine Art & Projects, Mendrisio, Switzerland

1998
"John Baldessari, The Goya Series", Sonn-
abend Gallery, New York, NY
"Baldessari, 4 RMS W VU: WALLPAPER,
LAMPS AND PLANTS. NEW", Witte de
With, Rotterdam, The Netherlands
"Baldessari, 4 RMS W VU: WALLPAPER,
LAMPS AND PLANTS. NEW", Museum für
Gegenwartskunst, Zürich, Switzerland
"John Baldessari", Mai 36 Gallery, Zürich,
Switzerland
"Tele Dolca Llar & Baldessari 4 HAB a /
Vtes.: paper, pintat, llums I plantes. NOU",
Museu D'Art Contemporani, Barcelona,
Spain
"John Baldessari Recent Works", Charim
Klocker, Vienna, Austria
"John Baldessari, Commissioned Paintings",
Sonnabend Gallery, New York, NY

1997
"John Baldessari", Marian Goodman,
Paris, France
"John Baldessari 1990–1996", Galerie
Laage-Salomon, Paris, France
"John Baldessari", Margo Leavin Gallery,
Los Angeles, CA
"John Baldessari", Theoretical Events,
Napoli, Italy
"John Baldessari National City Paintings
from 1967 and 1996", Galerie Philomene
Magers, Cologne, Germany

1996
"John Baldessari", Hochschule für Ange-
wandte Kunst in Wien, Vienna, Austria

"John Baldessari" Jürgen Becker, Hamburg, Germany
"John Baldessari: National City", San Diego Museum of Contemporary Art, La Jolla, CA
"John Baldessari", Centro de Arte Moderna Jose de Azeredo Perdigao, Fundacao Calouste Gulbenkian, Lisbon, Portugal

1995
"John Baldessari", Margo Leavin Gallery, Los Angeles, CA
"John Baldessari: A Retrospective", Cornerhouse, Manchester, England; Serpentine Gallery, London, England; Württembergischer Kunstverein, Stuttgart, Germany; Moderna Gallerija Ljubljana, Ljubljana, Slovenia; Museet For Samtidskunst, Oslo, Norway; Fundacao Calouste Gulbenkian, Lisbon, Portugal

1994
"Artist's Choice: John Baldessari, e.g. Grass, Water Heater, Mouths & etc. (for John Graham)", The Museum of Modern Art, New York, NY

1990
"John Baldessari", The Museum of Contemporary Art, Los Angeles, CA. Travelling to: The San Francisco Museum of Modern Art, San Francisco, CA; The Hirshhorn Museum and Sculpture Garden, Washington D.C.; The Whitney Museum of American Art, New York, NY; Musee d'Art Contemporain de Montreal, Canada

1989
"John Baldessari: Ni por esas" ("Not Even So"), Centro de Arte Reina Sofia, Madrid, Spain. Traveled to: CAPC Musee d'art contemporain, Bordeaux, France; IVAM Centro Julio Gonzalez, Valencia, Spain

1986
"John Baldessari: MATRIX BERKELEY 94", University Art Museum, University of California, Berkeley, CA

1985
"John Baldessari", Le Consortium, Centre d'art Contemporain, Dijon, France

1981
"John Baldessari: Work 1966–1980", The New Museum, New York, NY. Traveled to: The Contemporary Arts Center, Cincinnati, Ohio; Contemporary Arts Museum, Houston, TX; Municipal Van Abbemuseum, Eindhoven, The Netherlands; Museum Folkwang, Essen, Germany

GRUPPENAUSSTELLUNGEN/ GROUP EXHIBITIONS
(Auswahl/Selection)

1999
"Sight Gags, Grotesque, Caricature, and Wit in Modern and Contemporary Drawing", The Museum of Modern Art, New York, NY
"Crosscurrents: New Art from MoMA", Hara Museum of Contemporary Art, Tokyo, Japan
"Tomorrow for Ever – Photographie als Ruine", KunstHalleKrems, Basel, Switzerland
"Global Conceptualism: Points of Origin 1950s–1980s", Queens Museum of Art, Queens, New York, NY
"Circa 1968", Museu Serralves, Museu De Arte Contemporanea, Porto, Portugal
"Examining Pictures/Exhibiting Paintings", The White Chapel Gallery, London, Great Britain
"Trouble Spot. Painting", MUKHA, Antwerp, Belgium

1998
"Big As Life: An American History of 8 mm films", The Museum of Modern Art / San Francisco Cinematheque, San Francisco, CA
"Corpos Em Transito", Galeria Pedro Olivera, Porto, Portugal
"The Lure of Language", Lopdell House Gallery, New Zealand
"Amnesty International Benefit Drawing Show", Paula Cooper Gallery, New York, NY
"Konzeptionelle Arbeiten der 1960er bis 1980er Jahre", Galerie Rüdiger Schöttle, Munich, Germany
"Fuck You We Paint", New Image Art, Los Angeles, CA
"Breaking Ground", Marian Goodman Gallery, New York, NY
"Art Without the Unique, Edition Artelier, 1958–1998", Künstlerhaus Graz, Austria
"Artificial Figuracions Contemporanies", Museu d'Art Contemporani de Barcelona, Barcelona, Spain
"The Information Age: Baldessari, Berry, Huebler, Weiner, 1969–1971", Susan Inglett, New York, NY
"Travel & Leisure", Paula Cooper Gallery, New York, NY
"Conceptual Photography", David Zwirner, New York, NY
"Artistes et Photographes", Galerie Laage-Salomon, Paris, France
"Thirty five years at Crown Point Press: Making Prints, Doing Art", University Art Gallery, San Diego, CA
"Double Trouble, The Patchett Collection", The Museum of Contemporary Art, San Diego, CA

1997
"La Biennale di Venezia: 47th International Art Exhibition", Venice, Italy

"Scene of the Crime", UCLA at the Armand Hammer Museum, Los Angeles, CA
"Sunshine & Noir. Art in L.A. 1960–1997", Louisiana Museum of Modern Art, Humlebaek, Denmark. Traveled to Kunstmuseum Wolfsburg, Germany; Castello di Rivoli, Museo d'Arte Contemporanea, Italy; UCLA Arm and Hammer Museum of Art, L.A., CA
"Livres D'Artistes", Bibliotheque Nationale de France, Paris, France
"The Pleasure of Reading", John Gibson Gallery, New York, NY

1996
"Painting into Photography: Photography into Painting", The Museum of Contemporary Art, Miami, Florida
"Hall of Mirrors: Art and Film since 1945", MOCA, Los Angeles, CA
"Think Print, Books to Billboards, 1980–95", The Museum of Modern Art, New York, NY
"Comme un oiseau", Foundation Cartier pour l'art contemporain, Paris, France
"Prospect 96", Frankfurt, Germany
"Wheel of Fortune – Artists Interpret the Tarot", Lombard/Freid Fine Arts, New York, NY
"John Baldessari, Vito Acconci, Les Levine and Lawrence Weiner", Mai 36 Galerie, Zürich, Switzerland
"1965–1975: Reconsidering the Object of Art", MOCA, Los Angeles, CA
"Chain Reaction: An Abbreviated Survey of Idea-Based Art", Track 16 Gallery, Santa Monica, CA
"25 Years: An Exhibition of Selected Works", Margo Leavin Gallery, Los Angeles, CA
"Ideal Standard Summertime", Lisson Gallery, London, England,
"Untitled (Reading Room)", Margo Leavin Gallery, Los Angeles, CA

"Reflected Image: A selection of Contemporary Photography from the LAC Collection, Switzerland", Centro perl'Arte Contemporanea Luigi Pecci, Prato, Italy
"Go Figure", Patricia Faure Gallery, Santa Monica, CA
"John Baldessari and Bernd and Hilla Becher", Kamakura Gallery Tokyo, Japan

1994
"In the Field: Landscape in Recent Photography", Margo Leavin Gallery, Los Angeles, CA

1993
"Construction. Quotation: Collective images in Photography", Sprengel Museum Hannover, Germany

1992
"More than One Photography: Works since 1980 from the Collection", Museum of Modern Art, New York, NY

1991
"Devil on the Stairs; Looking Back at the Eighties", Institute of Contemporary Art, Philadelphia, PA. Traveled to Newport Harbor Art Museum, Newport Beach, CA
"Motion and Document: Sequence and Time: Eadward Muybridge and Contemporary American Photography", National Museum of American Art, Smithsonian Institute, Washington, D.C.; Addison Gallery of American Art, Philips Academy, Andover, MA; Long Beach Museum of Art, Long Beach, CA; Henry Art Gallery, University of Washington, Seattle, Washington; Wadsworth Athenaeum, Hartford, Connecticut; International Museum of Photography at George Eastman House and Visual Studies Workshop, Rochester, NY

1990
"Art in Europe and America: The 1960s and 1970s", Wexner Center for the Visual Arts, Ohio State University, Columbus, Ohio

1989–90
"John Baldessari, Robert Rauschenberg, James Rosenquist, Tishan Hsu, Holt Quentel", Busche Galerie, Cologne, Germany

1987
"Los Angeles Today: Contemporary Visions", Amerika Haus, Berlin, Germany; The Los Angeles Municipal Art Gallery, Los Angeles, CA

1986–88
"Individuals: A Selected History of Contemporary Art 1945–1986", The Museum of Contemporary Art, Los Angeles, CA

1985–86
"Carnegie International: Contemporary Art – Europe and America in Pittsburgh", Museum of Art, Carnegie Institute Pittsburgh, PA

1983
"Whitney Biennial Exhibition", (also included in Whitney Biennial in 1979, 1977, 1972 and 1969), Whitney Museum of American Art, New York, NY

1982
"documenta 7", Kassel, Germany
"Photography Used in Contemporary Art, In and Around the 70's", National Museum of Modern Art, Tokyo, Japan

1978
"Art About Art", Whitney Museum of American Art, New York, NY

1972
"documenta 5", Kassel, Germany

MONOGRAPHIEN/
CATALOGUES (one person)

1999

John Baldessari: Tetrad Series, Marian
Goodman Gallery, New York, NY

1998

Baldessari – RMS W VU: WALLPAPER,
LAMPS AND PLANTS. (NEW). Museum für
Gegenwartskunst, Zürich, Switzerland

1996

Davies, Hugh & Hales, Andrea. John Baldes-
sari: National City. Museum of Contemporary
Art, San Diego, CA
Prinzhorn, Martin. John Baldessari. Hoch-
schule für angewandte Kunst in Wien,
Vienna, Austria
Pyo. John Baldessari. Pyo Gallery, Seoul,
Korea

1995

Snoddy, Stephen. This Not That. Cornerhouse,
Manchester, England

1994

Varnedoe, Kirk and John Baldessari.
Artist's Choice: John Baldessari, e.g. Grass,
Water, Heater, Mouths & etc. (for John
Graham). The Museum of Modern Art,
New York, NY

1990

van Bruggen, Coosje. John Baldessari. The
Museum of Contemporary Art, Los Angeles,
CA, Rizzoli, New York, NY

1989

No Por Esas / Not Even So: John Baldes-
sari, published by CAPC Museé d'art
contemporain de Bordeaux for exhibition
traveling to: Centro de Arte Reina Sofia,
Madrid, Spain, CAPC, Museé d'art Con-
temporain, Bordeaux, France, and IVAM,
Instituto Valenciano de Arte Moderno,
Valencia, Spain

1981

John Baldessari, essays by Marcia Tucker
& Robert Pincus-Witten and an interview by
Nancy Drew, published by The New Museum,
New York, NY; co-published with University
Art Galleries, Wright State University, Dayton,
Ohio. The New Museum
John Baldessari, introduction and interview
by Rudi Fuchs, published by Municipal Van
Abbemuseum, Eindhoven, The Netherlands;
Museum Folkwang, Essen, Germany, edited
by Jan Debbaut

TEXTE UND BÜCHER VOM
KÜNSTLER/WRITINGS AND BOOKS
BY THE ARTIST

1998

Zorro (Two Gestures And One Mark), Cologne
1998

1989

Lamb. Collaboration with Meg Cranston.
Valencia, Spain: IVAM Centro Julio Gonzalez

1988

The Telephone Book (With Pearls). Gent,
Belgium: Imschoot, Uitgevers for IC
The Life and Opinions of Tristam Shandy.
Thirty-nine photocollage illustrations for the
novel by Laurence Sterne; produced at San
Francisco as three volumes, in an edition of
400 sets, of which fifty are issues with a suite
of five lithographs by the artist. Produced
by Arion Press

1981

Close-Cropped Tales. Buffalo: CEPA Gallery;
and Buffalo: Albright-Knox Art Gallery

KRITIKEN/ARTICLES AND REVIEWS

1998

Schjeldahl, Peter. "Wonderful Cynicism: John
Baldessari", Village Voice, Feb. 4. issue
Johnson, Ken. "John Baldessari, The Commis-
sioned Paintings". The New York Times,
December 11, pg. B 37
Lawrence, Diane. "John Baldessari, the
Coagula interview", Coagula, March – April
#32, 1998, pp. 26 – 30
Tilroe, Anna. "Lachjese van verontschuligung,
Tv kijken in het museum met John Baldes-
sari", NCR Handelsblad, January 30, 1998,
p. CS7
Speigel, Olga. "Baldessari untima ina
intalacion de gran formato enel Macba",
La Vanguardia, July 11, 1998
Fintovoa, Rosario. "Un paradis per a teleadd-
dictes El Macba exposa les visions de tres
artistes nord-americanas", el Periodico,
July 15
Minjee Cho. "Create and Destroy", ARTnews
Summer 1998, p. 36

1997

McKenna, Kristine. "Turning Gray to Black
and White", Los Angeles Times, April 20,
1997, (calendar) p. 54 – 55
"Kunstmarkt", Frankfurter Allgemeine
Zeitung, Germany, July 19, Nr. 165 / p. 35
"Tips und Termine", Kölner Stadtanzeiger,
Germany, July 4, Nr. 154 / p. 5
Knight, Christopher. "An Enlightened Twist
on Tradition", Los Angeles Times, April 30,
F1 & F6
Pricenthal, Nancy. "John Baldessari", On
Paper The journal of Prints, Drawings and
Photography, May – June 1997, p. 38
Lindgard, Jade. "John Baldessari", Les
Inrockuptibles, Paris, 30 April – 6 May,
19 and insert
"John Baldessari le Manipulateur", Le Monde,
Paris, April 15, 22

Hüllenkremer, Marie. "Die Vergangenheit muß man zerstören", Kölner Stadt-Anzeiger, Cologne, Germany, June 10

1996
Meyer, James. "Reconsidering the Object of Art", Artforum, February, p. 78, 79, 109
Greene, Davis A. "1965–1975: Reconsidering the Object of Art", Frieze, January / February, p. 62
Kornblau, Gary. "1965–1975: Reconsidering the Object of Art", Art Issues, January / February, p. 36–37
Albertini, Rosanna. "John Baldessari: I colori Della Discordanza", Flash Art, Italia, December 1995 / January 1996, p. 57–60

1995
Relyea, Lane. "John Baldessari: Margo Leavin Gallery", Artforum, October, 1995, p. 107
"Buss Bets: Art", Buzz Magazine, May 1995, p. 25
Knight, Christopher. "A Mysterious Place Between Paintings and Photographs", Los Angeles Times, May 10, p. F1

1994
Kimmelman, Michael. "For Baldessari, de Chirico is Just One of the Guys", New York Times, April 10

1993
Smith, Roberta. "John Baldessari: Working Materials", The New York Times, September 17, p. C18

1991
"Collaboration John Baldessari / Cindy Sherman", Parkett, #29, September, pp. 28–73, illus.; articles by Howard Singerman, Thomas Lawson, Patrick Frey, James Lewis, Dave Hickey, Susan A. Davis
Woodward, B. Richard. "Just Who Begat Whom?", World Monitor, July, pp. 58–60

FILME VOM KÜNSTLER/ FILMS BY THE ARTIST

Isocephaly, 1968, Super-8, color, 3 minutes
What to Leave Out, 1968, Super-8, color, 3 minutes
Cremation, 1970, 16 mm, black-and-white, 10 minutes
New York City Art History, 1971, Super-8, color, 3 minutes
New York City Postcard Painting, 1971, Super-8, color, 3 minutes
Waterline, 1971, Super-8, black-and-white, 3 minutes
Dance, 1971, Super-8, color, 3 minutes
Minimalism, 1971, Super-8, black-and-white, 3 minutes
Tabula Rasa, 1971, Super-8, black-and-white, 3 minutes
Black-Out, 1971, Super-8, black-and-white, 3 minutes
Easel Painting, 1972–73, Super-8 film loop (originally in 16 mm), color, 34 seconds
Time-Temperature, 1972–73, Super-8 film loop (originally in 16 mm), color, 4 minutes, 56 seconds
Water to Wine to Water, 1972–73, Super-8 film loop (originally in 16 mm), color, 36 seconds
The Hollywood Film, 1972–73, Super-8 film loop (originally in 16 mm), color, 66 seconds
Title, 1973, 16 mm, black-and-white and color, sound, 25 minutes
Throwing Leaves Back at Tree, 1973, Super-8 film loop, color, 3 minutes
Ice Cubes Sliding, 1974, Super-8 film loop, color, 3 minutes
Taking a Slate: Ilene and David (#1), 1974, Super-8 film loop (originally 16 mm), black-and-white, 20 seconds
Taking a Slate: Ilene and David (#2), 1974, Super-8 film loop (originally 16 mm), color, 3 minutes
Taking a Slate: David, 1974, Super-8 film loop (originally 16 mm), black-and-white, 48 seconds
Ted's Christmas Card, 1974, Super-8 film loop, color, 3 minutes
Script, 1973–77, 16 mm, black-and-white and color, sound, 25 minutes
Six Colorful Inside Jobs, 1977, 16 mm, color, 30 minutes

VIDEOFILME VOM KÜNSTLER/ VIDEOTAPES BY THE ARTIST

Folding Hat: Version 1, 1970, black-and-white, sound, 39 minutes
Folding Hat, 1970, black-and-white, sound, 30 minutes
Black Painting, 1970, black-and-white, 15 minutes
Black Curtain, 1970, black-and-white, sound, 15 minutes
Life Drawing, 1970, black-and-white, 30 minutes
I Will Not Make Any More Boring Art, 1971, black-and-white, 30 minutes
Walking Forward – Running Past, 1972, color, 20 minutes
I Am Making Art, 1971, black-and-white, sound, 19 minutes
Art Disasters, 1971, black-and-white, sound, 30 minutes
Police Drawing, 1971, black-and-white, sound, 30 minutes
Xylophone, 1972, black-and-white, sound, 5 minutes
Baldessari Sings LeWitt, 1972, black-and-white, sound, 19 minutes
Inventory, 1972, black-and-white, sound, 24 minutes

Teaching a Plant the Alphabet, 1972,
black-and-white, sound, 19 minutes
Ed Henderson Reconstructs Movie
Scenarios, 1973, black and-white, sound,
25 minutes
How We Do Art Now, 1973, black-and-white,
sound, 30 minutes overall
Segments: How Various People Spit Out
Beans, Comparing Two Sounds, A 20" Tape,
The Eye Does Not Naturally Pan, Cigar
Lexicon, On Making a Masterpiece
Haste Makes Waste, 1973, black-and-white,
video loop, 2 minutes
Practice Makes Perfect, 1973, black-and-
white, video loop, 2 minutes
The Way We Do Art Now and Other Sacred
Tales [The Birth of Art and Other Sacred
Tales], 1973, black-and-white, sound,
30 minutes overall
Segments: Some Words I Mispronounce,
You Tell Me What I Do, Anna Names Animals
She Has Never Seen, Taping a Stick; Lifting
It from the Other End, No Dice, Talking With
One Knee to Another, Examining Three 8d
Nails, What Follows Is What He Liked to Do
Best, For Sylvia Plath, A Riddle, Insincerely
Promising a Cat a Carrot, A Sentence
with Hidden Meaning, For Marcel Proust,
Close-up, Flight Bag (This is a kind of inte-
resting object …), It is Cruel to Put a Dog
on a Mirror, The Way We Do Art Now
(The Birth of Abstract Art)
The Sound Made By Kicking a Bottle, 1973,
black-and-white, sound, 3 minutes
Ed Henderson Suggests Soundtracks for
Photographs, 1974, black-and-white, sound,
28 minutes
The Italian Tape, 1974, black-and-white,
sound, 8 minutes
Six Colorful Tales: From the Emotional
Spectrum (Women), 1977, color, sound,
17 minutes
Two Colorful Melodies, 1977, color, sound,
6 minutes

CURATORIAL EXHIBITIONS

1994
The Museum of Modern Art, New York, NY,
"Artist's Choice: John Baldessari"

1993
The Museum of Contemporary Art,
Los Angeles, CA, "Not Painting: Some Views
from the Permanent Collection"

Spectrum – Internationaler Preis für Fotografie
der Stiftung Niedersachsen /
Spectrum – International Award for Photography
of the Foundation of Lower Saxony

BALDESSARI
While something is happening here,
something else is happening there

Works 1988–1999

Sprengel Museum Hannover
26.9.1999 – 2.1.2000
und/and
Staatliche Kunstsammlungen Dresden,
Gemäldegalerie Neue Meister
16.1. – 2.4.2000

© 1999 Stiftung Niedersachsen, John Baldessari
und Autoren/and authors

Ausstellung und Katalog/Exhibition and catalogue:
John Baldessari, Antonio Homem, Thomas Weski

Übersetzungen/Translations:
John Brogden, Dortmund
(Texte/Texts Diedrich Diederichsen, Thomas Weski)
Michael Stoeber, Hannover
(Text/Text Cranston)

Gestaltung und Satz/Design and type setting:
Büro für Buchgestaltung Bernd Kruhl,
Isernhagen

Gesamtherstellung/Printed by:
Schäfer*art* in Th. Schäfer Druckerei GmbH
Hannover

Verlag der Buchhandlung Walther König, Köln
ISBN 3-88375-396-3

Printed and bound in Germany

Organisation/Organisation:
Kim Schoenstadt, Studio Baldessari,
Santa Monica;
Laura Bloom und/and Jason Ysenburg,
Sonnabend Gallery, New York;
Philomene Magers, Philomene Magers -
Monika Sprüth, München/Köln;
Rino Martusciello, Massimo Martino
Fine Arts & Projects, Mendrisio;
Monika Klingele, Mai 36 Galerie, Zürich;
Wolfgang Häusler, Häusler Kultur-
management GmbH, München;
Joe Reorda, Liam Ahern, Margo Leavin
Gallery, Los Angeles;
Jill Sussman, Andrew Richards,
Marian Goodman Gallery, New York

STIFTUNGNIEDERSACHSEN

Die Deutsche Bibliothek – CIP Einheitsaufnahme

Baldessari : while something is happening here, something else is happening there ;
works 1988–1999 ; [Sprengel-Museum Hannover, 26.9.1999 – 2.1.2000
und Staatliche Kunstsammlungen Dresden, Gemäldegalerie Neue Meister, 16.1. – 2.4.2000] /
mit Texten von Meg Cranston, Diedrich Diederichsen und Thomas Weski.
[Übers. John Brogden ; Michael Stoeber]. – Köln : König, 1999
ISBN 3-88375-396-3